Publisher: Institute of American Indian
and Alaska Native Culture and Arts Development
On the Campus of the College of Santa Fe,
1600 St. Michael's Drive
P.O. Box 20007
Santa Fe, New Mexico 87504
Design and Layout: Michael Gray (Chippewa-Cree)
Director of Communications: Clifford LaFramboise (Chippewa)
Publication Management: Julia D'Arcy
Printed in U.S.A. by R.R. Donnelley & Sons Company
ISBN #1-881396-04-5

Creativity Is Our Tradition

Three Decades of
Contemporary
Indian Art

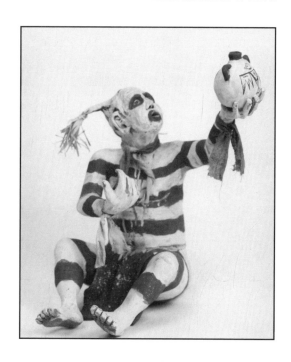

at the
INSTITUTE OF AMERICAN
INDIAN ARTS

BY
RICK HILL
MUSEUM DIRECTOR

ESSAYS
BY
NANCY MARIE MITCHELL
AND
LLOYD NEW

SANTA FE, NEW MEXICO

1992

TABLE OF CONTENTS

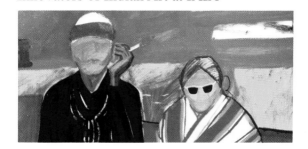
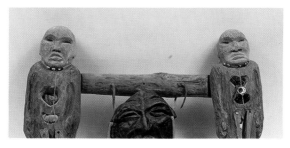
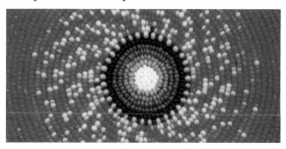

FOREWORD

1992 is an important year for American Indians and Alaska Natives. Not because it is the anniversary of the arrival of Columbus, but because we are in a period of great change, a period when Indian law, Indian government, Indian education, Indian economic development, Indian environmentalism and Indian spirituality are undergoing revitalization and gaining recognition in wider circles of influence. We are stepping forward to reclaim our rightful place in the world community, bringing new skills, a renewed voice and a vital spirit. Part of that movement is also the reclamation of our cultural rights to determine who we are for ourselves. Art has played a vital role to Indians over the centuries in expressing that self-determined identity. Art is also our gift to the world.

1992 is the thirtieth anniversary of the birth of the Institute of American Indian Arts in Santa Fe, New Mexico. With this exhibition and the opening of the new IAIA Museum, we celebrate the role of the arts in liberating the Indian spirit and in bringing forth a vision that can drive the future generations of Indians. At this time, we also reflect on ourselves as a national educational institution that focuses on Indian art and what the arts will mean to the future survival of Indian nations. IAIA continues to evolve and we look forward to developing a campus here in Santa Fe.

It is a joy to see the creative works of the former students of IAIA as represented in this exhibition. They should be thanked for the pleasure and insight their works provide us. It is also joyful to realize the experiment in the arts that began in 1962 is not over. The current students of IAIA carry on the honorable tradition of creativity. They will continue to express themselves as Indians and as individuals, through the arts. The artists ultimately share in this celebration as the new IAIA Museum provides a national showcase for the artistic achievements of our students and will be a forum for the continuing dialogue on the role of art among Indians.

We welcome you to that dialogue and hope that you experience art as we do. We hope that you can share our visions and our creativity and for once, begin to see the world through Indian eyes, and maybe at the same time, see us on our own terms.

Kathryn Harris Tijerina

Kathryn Harris Tijerina / Comanche
President IAIA

ACKNOWLEDGMENTS

It is always difficult to thank everyone who has been involved in the development of a new museum and a premiere exhibition. The opening of the new museum of IAIA is an important milestone in the development of Indian art. A generation of people have passed through the art studios of IAIA, and it is time to tell what the arts have meant for the Indian students of IAIA. As we consider all of the ramifications of the Columbian legacy, opening this museum in 1992 becomes even more significant. Not only is 1992 the thirtieth anniversary of IAIA and a time to celebrate our successes, it is a time for IAIA, as a congressionally chartered institution, to take a new leadership role in the arts and assure that, despite the clash of cultures that has occurred in the last five hundred years, art will remain the vital way to express what is unique to us as Indians.

The IAIA Museum would not have been possible if it was not for effort of all of the people of the IAIA community over the last three decades. William S. Johnson, Chairman of the Board of Trustees, is recognized for his leadership and dedication related to acquisition of the Museum building and its renovation.

Of unmatched service during those years has been Chuck Dailey. Under his guidance, the National Collection of Contemporary Indian Art was assembled. His dedication to the students at IAIA has left an unforgettable mark on the nature and strength of the collection. He has also helped many of the Indian museum people working in museums today learn the importance of operating their own museums. This exhibition comes from that inspirational legacy and all of the museum staff's respect for the years of commitment to IAIA that Chuck Dailey has evidenced.

It also comes from a vision about art and Indians that was given form through the efforts of Lloyd New. His personal vision drove IAIA to become the leading force it is. The IAIA Museum is dedicated to his belief that art is the springboard to manifest a productive and creative Indian future.

We thank the artists for their work and their comments that have formed the intellectual core of this exhibition. Very early in the development of this exhibition, we had the valuable insight and assistance of several Indian art curators, including Arthur Amiotte, Peter Jemison, Gerald McMaster, Lloyd New, Margaret Archyleta, Manuelita Lovato, Frank LaPena, James Luna, Lloyd Oxendine, and Tom Hill. Locally, we had the help of Indian curators who work at the area museums, including Soge Track of the Millicent Rogers Museum; Tessie Naranjo of the Santa Clara Pueblo Cultural Center; Paula Rivera of the Museum of Indian Arts and Culture; Gary Roybal of the National Parks Service; George Rivera of the Poeh Center; and Eunice Kahn of the Wheelwright Museum. Several alumni of IAIA participated in a valuable conference on the history of IAIA and can be seen in the interactive video program, including Bill Soza, Alfred Young Man, Delmar Boni, Bruce King, Peter Jones, Karita Coffey, Linda Lomahaftewa, Larry Des Jarlais and Manuelita Lovato.

This exhibition and catalog could not have been possible without the generous support of the many financial supporters of the IAIA Museum. Major support for the opening exhibition was provided by the Rockefeller Foundation and by the Museum Founders and Charter Members. A generous grant from the IBM Corporation enables the IAIA Museum to provide a state-of-the-art collections management system and interactive video programming. Ann Roberts provided critical funding for this catalog.

The IAIA Development Office staff with the help of the members of the IAIA Foundation Board of Directors and other volunteers provided the critical planning and development of the private sector funding for the new IAIA Museum. JoAnn Balzer, on loan to IAIA from IBM Corporation, deserves special recognition for her efforts related to development of the museum computer collections management network and interactive video productions. Consultants to the Museum Lori Pourier, Richard Steckle, and Bruce Poster provided the museum with essential planning and development of the museum's overall marketing approach and development of the Museum Shop.

Many of the artists who attended IAIA have already passed on, but their work continues to inspire Indian thinking and creativity. No matter how good the opening of the new museum makes us feel, we take the time to remember all those who have passed on before us. Our voices join with theirs as we celebrate our tradition of creativity.

Rick Hill / Tuscarora
IAIA Museum Director
June 1992

viii

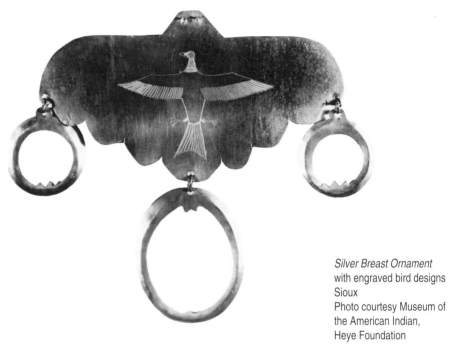

Silver Breast Ornament
with engraved bird designs
Sioux
Photo courtesy Museum of
the American Indian,
Heye Foundation

CHAPTER ONE
A TRADITION BEYOND DECORATION

The role of tradition in Indian art is a poorly understood concept. Tradition is commonly thought to be a style, a technique or form of expression that is tied to the past. To Indians it is dynamically expanding, a way of thinking passed on from our ancestors to which we are bound to add our own distinctive patterns.

Our past was never static. Our present is unique in Indian history. Our future depends upon how effectively generations to come will advance our characteristic ways of thinking. Lloyd New, past President of the Institute of American Indian Arts (1967-1978) stated in a 1968 issue of *Life* magazine, "... we believe tradition can be used as a springboard for personal creative action." (2)

Since the arrival of Columbus and subsequent immense social and political upheavals that have befallen our societies, Indians have found creative ways to survive the environment. Each generation of American Indians and Alaska Natives interprets and defines the relevance of our culture. That ever-changing evidence is found in the arts. The stream of regional diversity and individual expression are elements of Indian creativeness. As a founding principle in many Indian societies, freedom of expression fired our creative capacities to adapt and adjust to changing circumstances. A correct assessment of Indian art must be based on the concepts of creativity which expose deep cultural, religious, educational, political and economic influences to the Indian soul.

The Existing American Indian and Alaska Native Artistic Heritage

There exists an ancient artistic heritage in each American Indian and Alaska Native community from which contemporary art has sprung forth. Tradition is not replication of style, but the creative interpretation of the foundations of belief and thinking. The thinking itself evolved over the years, so the art would reflect the dynamics of that thinking. Many actual and symbolic references to those artistic traditions are still in use in contemporary Indian art. Thus many people have cultural expectations of art based upon the tradition of the past. However, that expectation does not require art to remain exactly the same over the generations. Because there exists a long history of change in the art of Indians, contemporary works continue to be a viable part of today's American Indian and Alaska Native world view.

"My culture is a living thing. It is not a static or dead way of life but an ever-changing metamorphosis of adaptation. My grandfather Ahvakan was among the generation to first experience the beginning of adaptation. He taught me that change was not the death of a culture … It is the basic nature of our way of life which I capture in my artwork. The tools may be modern, the material perhaps foreign to my grandfather, but the final statement would be the same." (3)

Larry Ahvakana, IAIA Alumnus

BELOW, Ralph Perea, Jicarilla Apache, in Silkscreen Class.

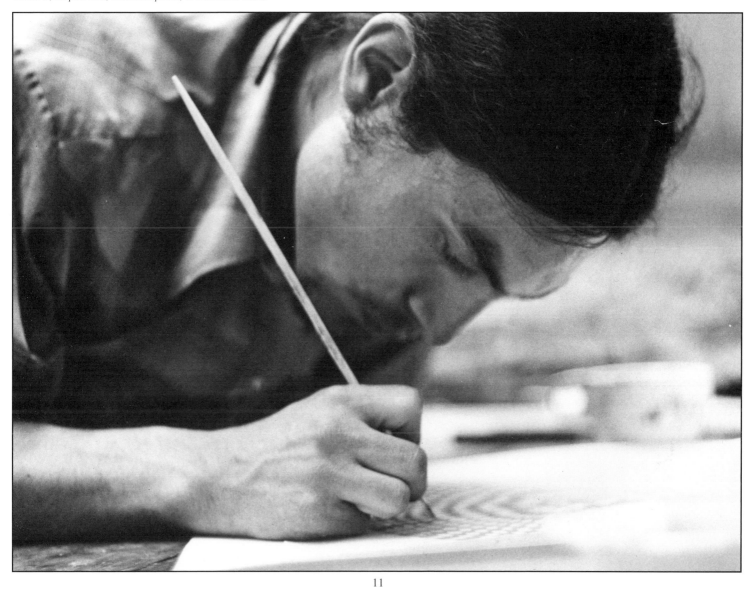

11

LOOKING AT INDIAN ART
THROUGH INDIAN EYES

Self-expression through song, dance, ritual and art have been important aspects of most cultures around the world. Each culture defines for itself what is the ultimate form of self-expression, and within each society there are certain individuals who excel in such expressions. Often the messages contained in such visual expressions are the only evidence we have of the thinking, beliefs, philosophies and actions of a previous non-writing civilization.

During consultations with Indian artists for the new National Museum of the American Indian, Indian artists provided insight as to how they see themselves. In their view Indian art exists beyond the walls of the cultural institutions. Some aspects of the arts are very private, for Indian eyes only. Arthur Amiotte summarized the different aspects of Indian art at a consultation in Albuquerque in 1991 as follows:

Indigenous internal art forms – Works which are unique and essential to the cultural identity of the Indian society.

Tourist arts – Works that are created for and in response to the outside visitor to the Indian community.

Regional artists – Artists who have significance to the local communities that identify with a regional culture, yet are relatively unknown beyond that region.

National artists – Artists who have developed a national profile in the Indian art world and have succeeded in obtaining recognition for their creativity in other art circles.

Truman Lowe, a Winnebago artist who teaches at the University of Wisconsin at Madison, believes that Indian artists create and use materials to convey thoughts about themselves and their people. At the Albuquerque consultation, Lowe said he feels contemporary Indian artists combine their own life experiences with the living cultural experiences of their community to fuel notions of what tradition really is. In this way, Lowe believes, materials are secondary to the intent of the work. He sees artists as the storytellers of their generation who interpret history for the sake of the future.

In general, Indian visual artists see their work as not being confined by any single definition. They believe they can take Euro-American concepts of art and mold them to their own needs without violating the cultural standards of their people. Art is a process, a vision, more than a product. Through the manifestation of such visions, the contemporary Indian artist feels he contributes to the transference of knowledge to the future generations. Indian artists understand the difference between ceremonial objects and visual art, most respect the value of ritual objects and will not violate sacred beliefs in their visual art. Finally, it is believed that Indian people must develop their own cultural context and definitions of art through time.

In this vein our exhibit was conceived in providing a way to see the value of art as Indians see it – as an ongoing tradition of creativity.

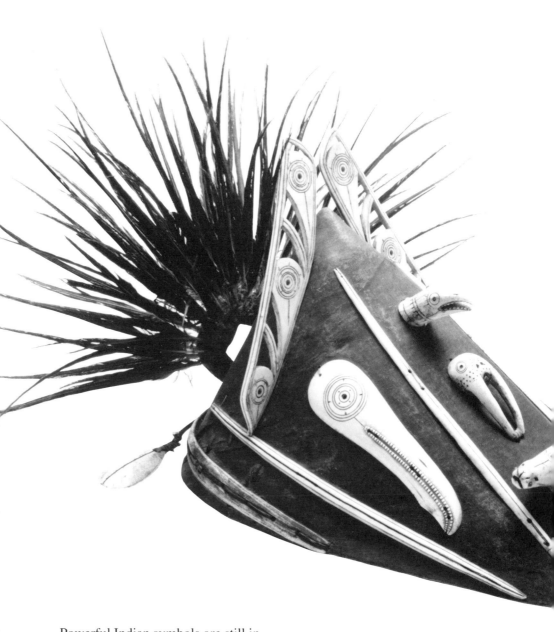

REGIONAL SYMBOLS
INSPIRED BY THE LAND

Early forms of artistic expression by Indians show the importance of the tribal identity. Combined with other forms of cultural identity, such as family, clan, medicine society, or sub-group that performs specific functions within the larger society, the individual Indian had many ways to express what was important.

The work shown in the Transitional Gallery of this exhibition presents examples of the diverse forms that individual expression has taken across the country.

Each region has its distinctive Indian culture that adapted to the character of that land. The landscape, animals, birds, fish, insects, serpents, trees, plants and sacred features of that particular region were generally reflected in the art of their nation. It is only natural to expect the arts of the Northeast to be different from the arts of the Southwest or of the Northwest Coast.

Indian culture is manifested in art through tribal, family and spiritual symbols that have created a vast visual literacy. Each generation carries the symbols of their ancestors forward, adding perspective to a symbol's significance and enlarging it's use in art.

Powerful Indian symbols are still in use in contemporary art and can be seen throughout this exhibition. The continuing use of such symbols in the archeological, historic and contemporary art of Indians is one way to understand the uniqueness of their art. These symbols allow tribal members to comprehend the art and provide an underlying commonality with other Indian viewers of the art:

ABOVE
Bering Sea Hunting Hat
Eskimo
Collection of the Museum Of Anthropology & Ethnology
Photo courtesy of the Smithsonian Institution

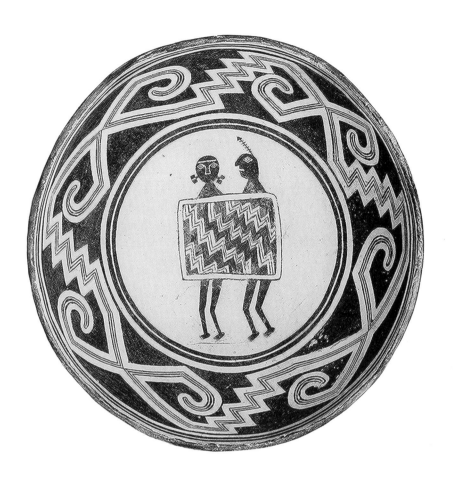

The Circle

The cycles of nature, the continuity of life and the unity of the people can be symbolized by a circle. Indians see themselves as fitting into the Circle of Life. It places them as relatives to the forces of the Universe (Father Sky, Mother Earth) and as relatives to the plants and animals. There is a communion with the spirits of their relatives within this Circle of Life. The circle, representing equality, sharing and unity, links all the aspects of culture together – art, religion, social organization, land use, ritual, language, law and lifestyle.

ABOVE
Mimbres Ware Bowl
1000-1050
Photo courtesy
Museum of the American Indian,
Heye Foundation

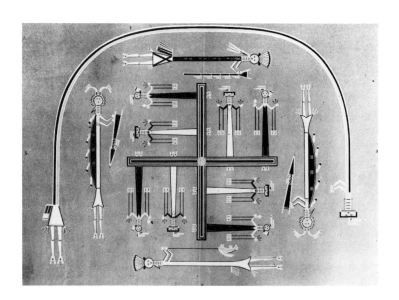

The Four Directions

The cardinal points of the compass are important as they represent special powers of the universe. The four directions are associated with symbolic colors or spiritual powers among many Indian nations. The number four becomes culturally significant and the concept of duality, or opposites, is also manifested in the use of opposing spheres that are represented by the four directions. Among some Indian nations, other directions, such as above, below and the center are also significant, completing their concept of the universe.

ABOVE
Navajo Sand Painting
Photo courtesy
the Smithsonian Institution

Celestial Symbols

The bodies of the universe and the forces of the seasons are given symbolic significance in Indian art. The skies are considered a special place where the spirit forces reside in the form of clouds, sun, moon, stars, winds, rain and lightning.

ABOVE
Plains Indian Moccasin
19th Century
Photo courtesy Bata Shoe Museum

Spirit Symbols

Sacred beings are stylized in the form of spirit symbols which are manifested in oral histories and personal visions. Such symbols are used by families and passed on to successive generations. Some are in use as personal totems during the life of the vision seeker. Others are given for personal use through ritual. Still others are commonly known in the oral traditions of the community. Some symbols are considered too sacred to be used in the visual arts and are restricted to ceremonial use only.

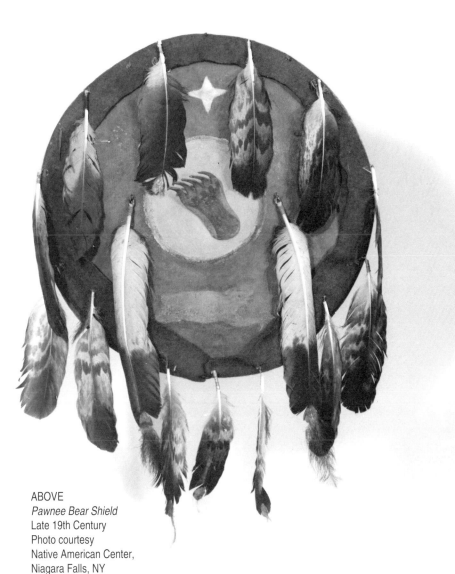

ABOVE
Pawnee Bear Shield
Late 19th Century
Photo courtesy
Native American Center,
Niagara Falls, NY

Landform Symbols

The elements of the environment – earth, water, mountains, springs, trees, rocks and landforms often take on spiritual connotations reflected in the arts. Each community has an environmental ethic which symbolizes their relationship to these landforms, relationships manifested in the arts in the form of symbolic design.

ABOVE
Birch Bark Cutouts
Ojibway
Photo courtesy
the Smithsonian Institution

Bird Symbols

Birds are viewed similarly, especially the eagle, raven, hawk, owl, and other birds of prey. Feathers become symbols of the powers of the bird and are used directly or in symbolic form in Indian art. Bird Spirits communicate with the Spirit Beings in the Sky World and can bring humans special wisdom, warnings and ways to carry the human concerns to the spirit world.

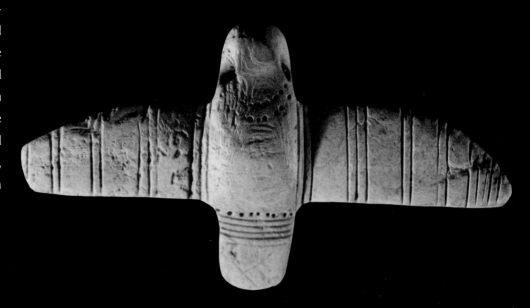

ABOVE
Shell Bird
Iroquois
17th Century
Photo courtesy
Canandagua Historical Society

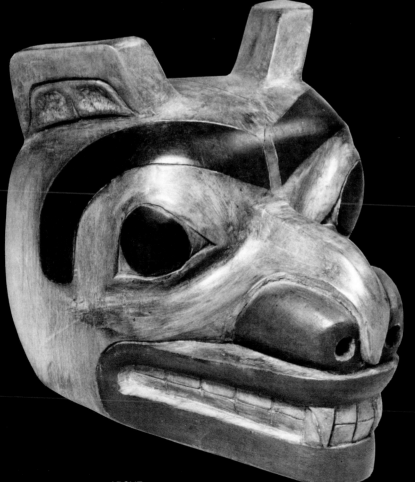

Animal Symbols

Indians believe in animal spirits and their ability to communicate with humans. Animals can share their protective or curative power, knowledge and experiences. This sharing is represented by the use of animal symbols.

ABOVE
Bear Mask
Photo courtesy
Indian Art Centre,
Ottawa, Canada

THE SOUTHEAST

In the Southeast, the Cherokee Indians believe the universe is composed of three main levels – the Upper World which represents stability; the Lower World which represents disorder and this World which represents balance. Special powers are also attributed to the Seven Directions: Above and Below which represent the Creator and Giver of Life; the Four Directions where North is the blue, cold power of trouble; South is the white, warm, peaceful power of happiness; East the red, fire power of life and West, the black power of the souls of the dead. Cherokees also believed that the Center is an important place where humans resided.

Animal symbols common in Southeastern Indian oral traditions are the Deer as a symbol of purity; the Eagle as a symbol of power and the Rattlesnake as a leader of the reptiles.

This Cherokee split river cane basket is typical of storage and transporting containers used throughout the Southeast. The native technique of twill plaiting is incorporated, as are the typical colors of red, black and natural cane, adding a decorative motif of geometric shapes. A double weave, used for strengthening the basket, sometimes rendered it water tight.

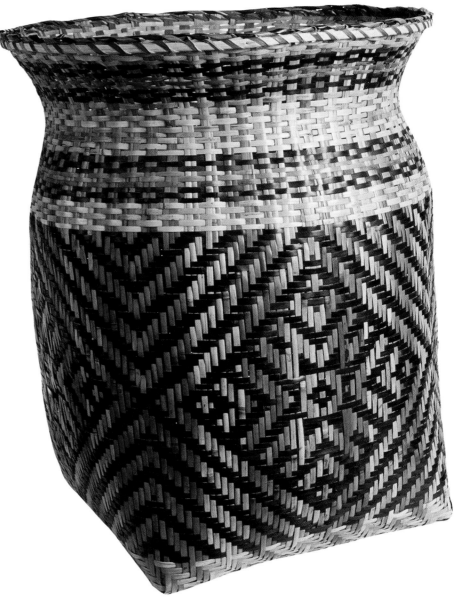

This work by T.A. Sunshine King was inspired from incised shell discs. The reposed copper shows an anthropomorphized eagle being who wears a copper bird beak mask. The figure is carrying a ceremonial copper wand and is dressed in a feather cape.

A modern version of symbolism from the Moundbuilder Cultures of the Southeast, Southeastern stoneware features images of mythic and heroic figures in association with the powers of animals. Some of the most creative and visually exciting work was done by Indian cultures prior to contact with Europeans. The use of incised shell, incised and decorated ceramics, carved stone pipes, hammered copper and elaborate clothing were all witnessed by the first Spanish explorers to visit the area in 1540. Animal, bird and reptile symbols predominate. Male figures in Moundbuilder art are often wearing robes of feathers as if in a state of transformation. The art of the era shows the dances and how the leaders of those rituals must have dressed. Designs from shell gorgets represent common symbols used in much of the Moundbuilder art. The Cross is a symbol of the Four Directions. The Circle with scalloped edges represents the sun. Eye symbols are common, often associated with hand images.

ABOVE
Pre-Columbian Serpent Design, T.A. Sunshine King
Yuchi
Stoneware
9-1/2" diameter
Acquired: 1979
IAIA Permanent Collection: YC-10

GREAT LAKES

My music reaches to the sky
The sky loves to hear me.

Chippewa Song

The Woodland region also includes the Great Lakes area. The art is similar, but has some distinctive aspects. Among the Great Lakes Indians, effigy mounds were built from A.D. 700 to A.D. 1000. The Misshepezhieu, the Horned Serpent, was believed to live in the lakes and streams, an underwater spirit that often drowned people, pulling them into the Underground Place.

Above the earth lived the Thunderbirds, with their power of war and lightning as they flapped their wings. Contemporary Ojibwa artist George Morrison of Grand Portage, Michigan, describes his artistic search for reality as being tied to the traditional Great Lakes Indian beliefs in "the power of the rocks, the magic of the waters, the religion of the trees, the color of the wind and the enigma of the horizon." (4)

Stylistically, the art of the Great Lakes represent a change from the semi-realistic floral patterns of the Northeast, combining it with the geometric patterns of the Great Plains. This can be seen in the beaded child's apron in this exhibit. Symmetry and harmonious use of shape and color are strong design principles. Ruth Phillips, an art historian, describes Great Lakes Indian art in her book Patterns of Power, as "an ancient repertory of geometric motifs, used to communicate the immaterial manifestations of 'manitos' (powerful spirits)." (5)

This piece is a very classic example of Woodland Indian art, showing how ideas of visual harmony are translated in glass beads obtained from traders. The use of glass beads is often thought to be "traditional" but is a relatively new innovation among Indians. Some scholars believe the Woodland Indians learned this style of floral design work from European missionaries, but their early etchings and paintings demonstrate the use of such symmetry, confirming this style had been employed since at least the time of contact. Even if there were a cross-cultural influence, the Great Lakes Indians believed that this style best represented their world view at that time

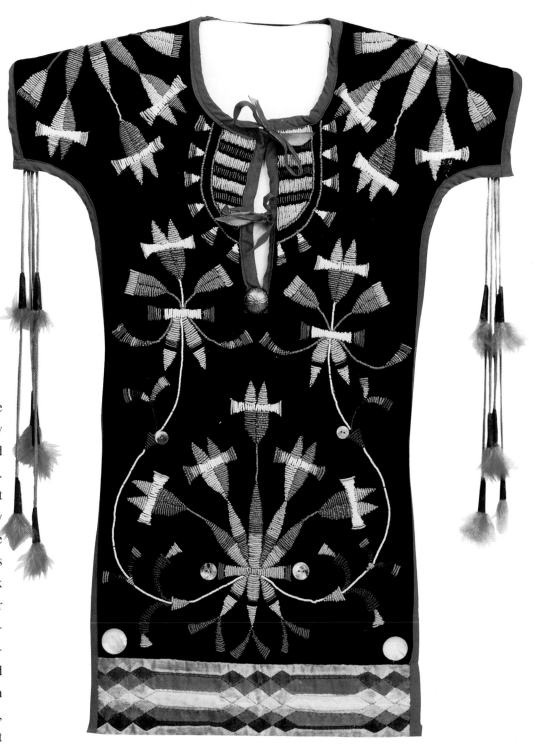

ABOVE
Child's Apron, Unknown Artist
Chippewa (Ojibwa)
Glass beads, feathers, shell, silver on velvet cloth
26-1/2" x 9-1/2"
Acquired: 1971
Edna Massey Collection
IAIA Permanent Collection: CHP-143

THE GREAT PLAINS

The wind, the wind
Shakes my tipi, shakes my tipi,
And sings a song for me
And sings a song for me.

Kiowa song

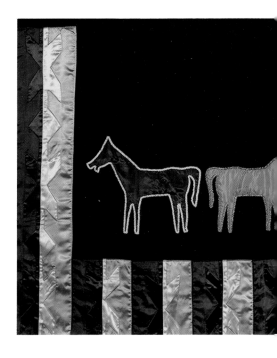

The ancient art of the Plains Indians included painted and incised rock art in both symbolic and representational designs. Generally, men made figurative designs of the hunt, battles and adventures of heroism.

Women painted more abstract geometric patterns, some of which were inherited. The Feathered Circle, symbolizing the head dress of the eagle or the rays of the sun were designs on men's painted buffalo robes. Women's robes used geometric designs. Plains Indian art of the nineteenth century became more interesting when quality of craftsmanship increased, due in a sense to the introduction of European trade tools and materials. A new sense of design, pattern and workmanship emerged as a further function of an object.

Plains Indian's aesthetics promoted the ideas of appropriateness of design to function; harmony of form, color and line used together to create a total object of beauty.

Talent, creativity, innovation and technical skill were recognized and encouraged, within the overall framework of tribal design principles. Animals with special symbolic significance for the Plains Indians included the buffalo as a sacred source of food; the eagle as a sacred messenger; the turtle as a symbol of the earth and longevity; the elk, a symbol of beauty and love; Coyote, a Trickster; wolf, a powerful animal spirit and bear, a protector in battle.

This work is evidence of the Plains Indian's belief in lizards, turtles and amphibians as symbols of protective power. Amulets were made in the shape of a protective figure, usually according to dreams. Among some Plains Indians, beaded amulets such as this one, were used to hold the dried umbilical chord of children. The amulet would be tied to the baby carrier and was thought to bring a hope for long life. The turtle was regarded with great respect and the beaded fetish was a good luck amulet.

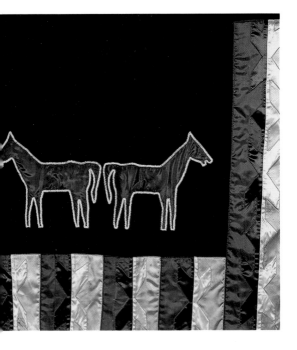

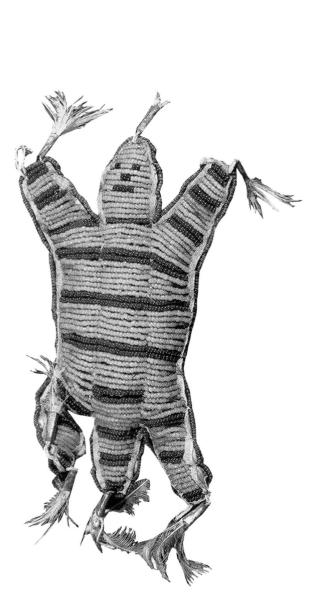

TOP LEFT
Traditional Blanket, Wendy Ponca,
Osage
Wool, ribbon, bells,
62" x 70"
Acquired: 1991
IAIA Permanent Collection: OS-63

TOP RIGHT
Effigy Beadwork, Unknown Artist
Plains
Glass beads, leather
1" x 2"
Acquired: 1984
Gift of Drs. Barbara & John Mickey
IAIA Permanent Collection: PLN-18

LEFT
Beaded Fetish, Unknown Artist
Plains
Glass beads, leather
5-1/2" x 3-1/2"
Acquired: 1983
Gift of Peter Carota
IAIA Permanent Collection: PLN-2

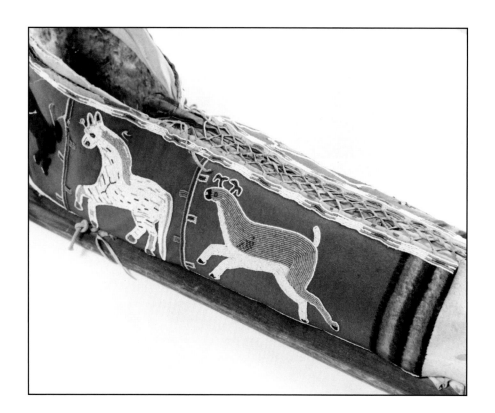

Kiowa cradle boards are an example of the visually spectacular works of the Plains Indians. They are characterized by a strong sense of design, with bold symmetrical patterns. Unlike other Plains tribes that usually decorated cradle boards with white beaded backgrounds, the Kiowa used reds, blues, and greens in highly imaginative ways. The particularly unusual work above is divided into two decorated panels, one of stylized floral patterns, the other an image of three animals – buffalo, horse and antelope.

ABOVE
Cradleboard, Unknown Artist
Kiowa
Leather, glass, beads, wood
43-1/4" x 10-3/4" x 11"
Acquired: 1962
IAIA Permanent Collection: KI-27

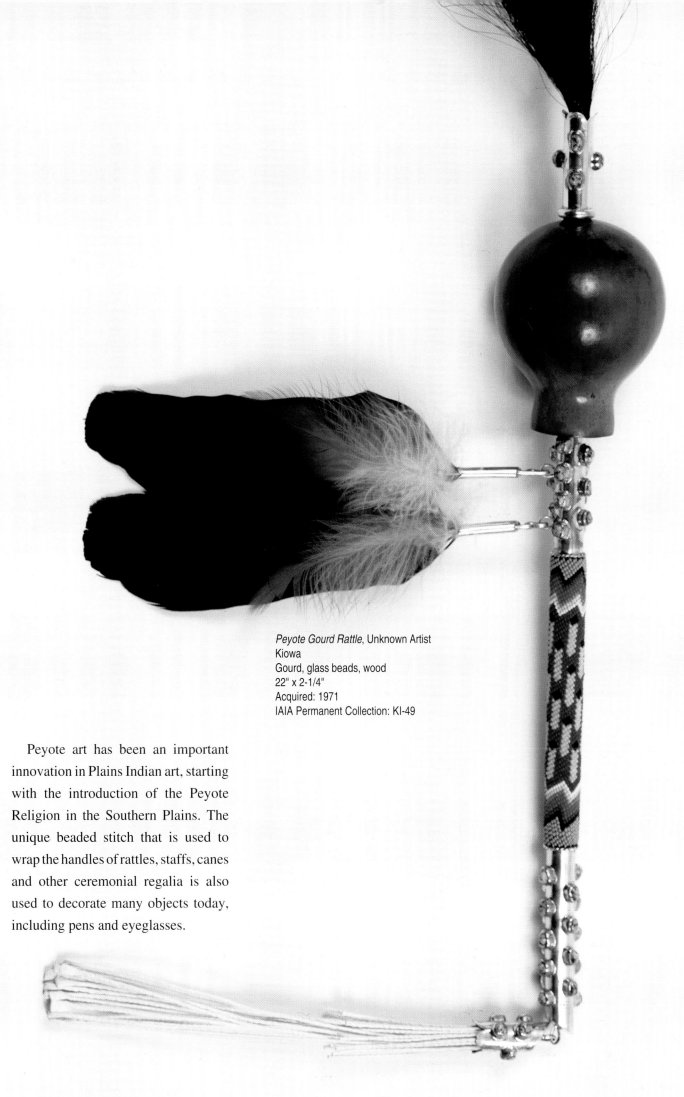

Peyote Gourd Rattle, Unknown Artist
Kiowa
Gourd, glass beads, wood
22" x 2-1/4"
Acquired: 1971
IAIA Permanent Collection: KI-49

Peyote art has been an important innovation in Plains Indian art, starting with the introduction of the Peyote Religion in the Southern Plains. The unique beaded stitch that is used to wrap the handles of rattles, staffs, canes and other ceremonial regalia is also used to decorate many objects today, including pens and eyeglasses.

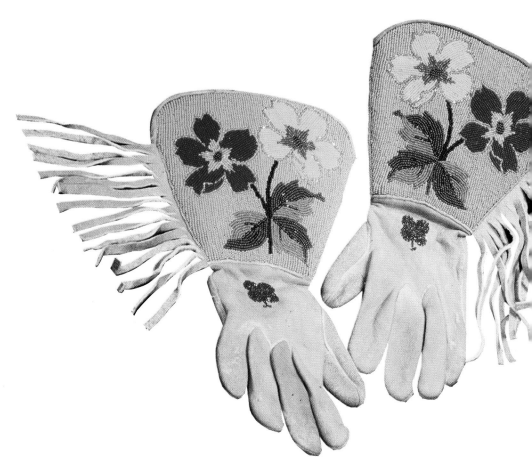

PLATEAU

The Plateau is a Plains-like region between the Rocky Mountains on the east, and the Cascade mountains on the west, covering Idaho, Nevada, Utah, parts of Montana and Oregon. This territory is occupied by the Nez Perce, Paiute, Shoshone, Ute, Spokane, Bannock, Coeur de Alene, Flathead and Kutenai Indians. They live in an environment which represents the transition from the Plains Indians to that of the Northwest Coast interior tribes.

Their region lacks clay for pottery and large wood for carving, so their culture makes great use of plant fibers. The focus of their art was painted hides, parfleche, (influenced by the presence of mountain buffalo) and woven corn husk bags. They excelled in beadwork after contact. Their designs have a unique combination of geometric patterns and floral design motifs.

ABOVE
Beaded Buckskin Gloves, Unknown Artist
Plateau
Glass Beads, leather
18-1/2" x 24-1/2"
Acquired: 1971
Edna Massey Collection: WD-12

Twined fiber bags were used for general storage purposes on the Plateau, just as rawhide was used on the Plains or bark was used in the Northeast. Before the time of contact food was gathered and stored in bags, by the Plateau Indian women, especially the Nez Perce. The bag is made by wrapping dyed corn husk around the woven fibers of the bag as it is created. Bear grass was used previously in their decoration. Cornhusk became more popular as a result of trade with white settlers, and as bear grass declined with western expansion. More recently, wool yarn has been used to increase the complexity of the geometric patterns on the bags. The front and back are often different. Larger "salli" bags, were used as saddle bags in the late 19th century. The Nez Perce women still make the corn husk bags incorporating the popular butterfly-like designs.

LEFT
Cornhusk Bag, Unknown Artist
Nez Perce
Cornhusk and yarn
10-1/8" x 8-1/2"
IAIA Permanent Collection: NP-28

SOUTHWEST

Song of the Sky Loom

Oh our Mother the Earth, oh our
 Father the Sky, Your children are
 we, and with tired backs We bring
 you the gifts that you love.
Then weave for us a garment of
 brightness:
May the warp be the white light of
 morning,
May the weft be the red light of
 evening,
May the fringes be the falling rain,
May the border be the standing
 rainbow.
Thus weave for us a garment of
 brightness
That we may walk fittingly where
 birds sing, That we may walk
 fittingly where grass is green,
Oh our Mother the Earth, oh our
 Father the Sky.

Tewa song

The Navajo believe two types of beings occupy this world. The mortal beings are the Earth People and the spiritual beings are the Holy People. Lessons are given to the Earth People from the underground Holy People, such as Spider Woman who taught women the art of weaving on a loom designed by Spider Man. Since that time, Navajo women have adopted weaving as a form of expressing their identity. Ritual, as a form of healing and worship, is a powerful vision of life that comes to reality through art. The object of the art is to illustrate the desire to maintain harmony and balance between the beings.

Common symbols in Pueblo art include representations of natural forms such as clouds, lightning, corn, prayer feathers, sacred mountains, rain and the sun. There are common animal symbols for the deer, bear and birds. Animals associated with water are also found in Pueblo art: tadpoles, toads, frogs, dragonflies, butterflies and the water serpent that is often seen on pottery designs. The Pueblo people use abstract designs and stylized shapes to express the power of the subject and identify the artist as a member of a particular Pueblo community.

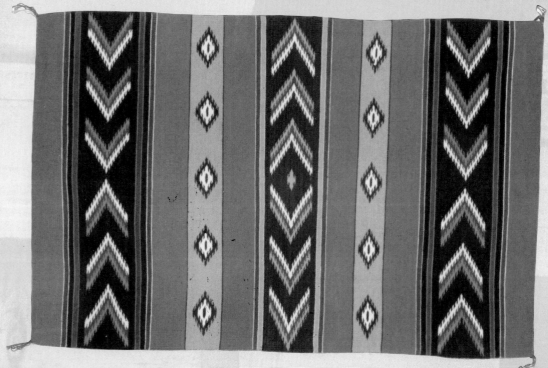

LEFT
Rug, Maggie Benwood
Navajo
IAIA Permanent collection N: 63

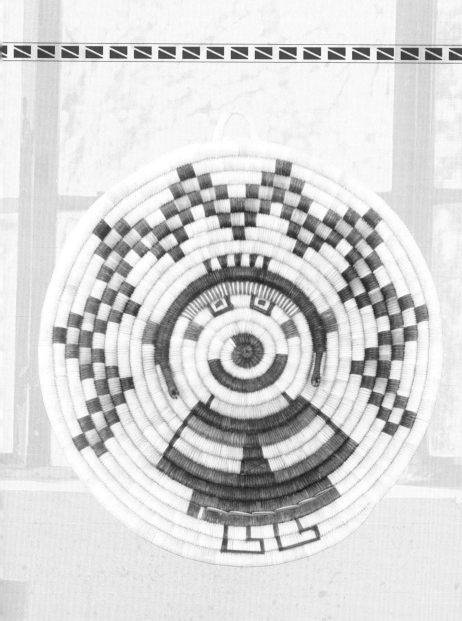

The Hopi make coiled baskets referred to as "the plaque upon which ground corn meal is placed." A bundle of yucca is wrapped to form a concentric coil with incorporated designs such as the example above, usually of spirit figures or sacred symbols. The method by which the coil is completed is said to have significance in determining the status of the maker. This basket has a completely finished rim, called a "closed gate," which means that the woman who made the basket was either a widow or older woman. These plaques are known to be made on Second Mesa, Arizona and the design represents a kachina figure.

ABOVE
Hopi Coil Basket, Unknown Artist
Hopi
Yucca
10-1/4" diameter
Acquired: 1971
IAIA Permanent Collection: H-96

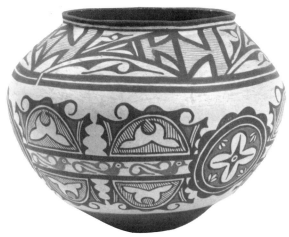

Clay, the most versatile material in the Southwest, has been used for centuries. Each tribal group developed its own distinctive style for ceramic containers, incorporating symbolic imagery in the painted designs. Gathering the clay is a sacred act in itself. To many Pueblo people, ceramics keeps alive the ancient traditional ways of relating to the earth.

This geometric designed "olla" is most likely from Zuni Pueblo, a finely painted design on a white slip base.

Kachina is a term applied to several hundred types of spirit beings of the Pueblo and Hopi Indians of the Southwest. The Kachinas live in the San Francisco Peaks to the south and west of the Hopi Reservation and visit the communities during rituals. Carved figures of the Kachinas are left behind in the villages after a visit from the spirit beings. The majority of the Rio Grande Pueblo people do not believe Kachina figures should be used in the visual arts, nor that the Kachina figures should be sold commercially. The Hopi from Arizona differ and Kachinas such as this one are created for sale.

ABOVE
Vase, Unknown Artist
Zuni
Clay
7-3/4" x 10" diameter
Acquired: 1971
IAIA Permanent Collection: PROP-216 U.A.

RIGHT
Black Ogre Kachina, Unknown artist
Hopi
Wood, hide, leather, feathers, silver
36" x 19"
Acquired: 1971
Edna Massey Collection
IAIA Permanent Collection: H-251

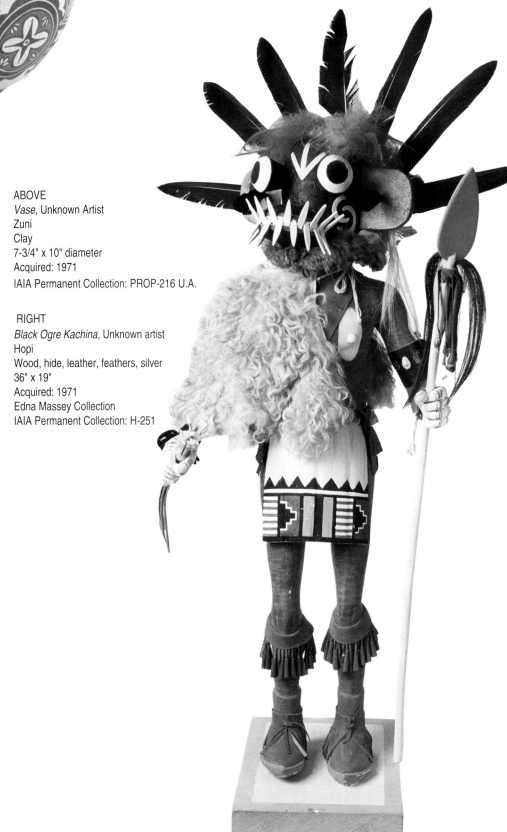

ABOVE
Thunderbird Necklace, Unknown Artist
Santo Domingo Pueblo
Turquoise, coral, automobile battery casing
24" diameter
Acquired: 1986
Gift of Drs. Barbara & John Mickey
IAIA Permanent Collection: SD-1

RIGHT
Bear Fetish, Tony Da
San Ildefonso Pueblo
Clay, shell beads and paint
6-1/2" x 10-1/2" x 4"
IAIA Permanent Collection: SILD-23

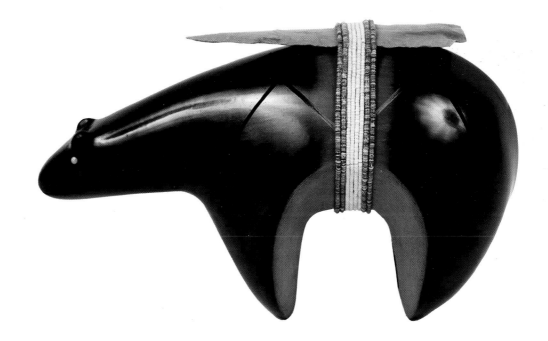

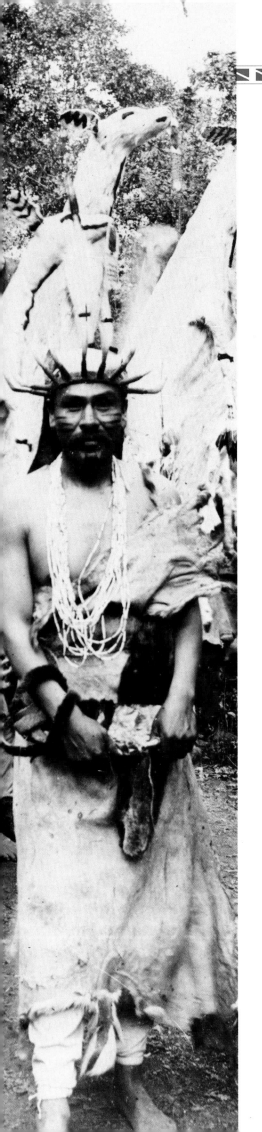

CALIFORNIA

For California Indians whose traditions remain strong, basketry has been an important way to express their ancient beliefs. The Pomo used baskets for gathering, storing, transporting and preparing foods, as baby carriers and ritual objects. Basketry was considered a gift delivered in the fifth and final creation of the Pomo world.

A variety of bird feathers were used: red from the woodpecker's head; yellow from the meadowlark; blue from the bluebird; iridescent green from the mallard duck.

The rim of many feather baskets are decorated with shell beads and California quail topknot feathers. Designs in the selected arrangements of the colored feathers had symbolic meaning. Small yellow diamond shapes on a red background are called "ants." Large yellow diamonds are referred to as "deer-back" or "potato-forehead" designs. The Pomo people were experts at weaving delicate bird feathers into symbolic patterns of a coil basket. These feather baskets are often referred to as "gift baskets" as they were given away on special occasions or were burned at funerals. Shell beads are attached to the rim of the basket.

Feather Basket, Unknown artist
Pomo
Vegetable materials, feathers
1-1/2" x 4" diameter
Acquired: 1983
Gift of Peter Carota
IAIA Permanent Collection: PO-3

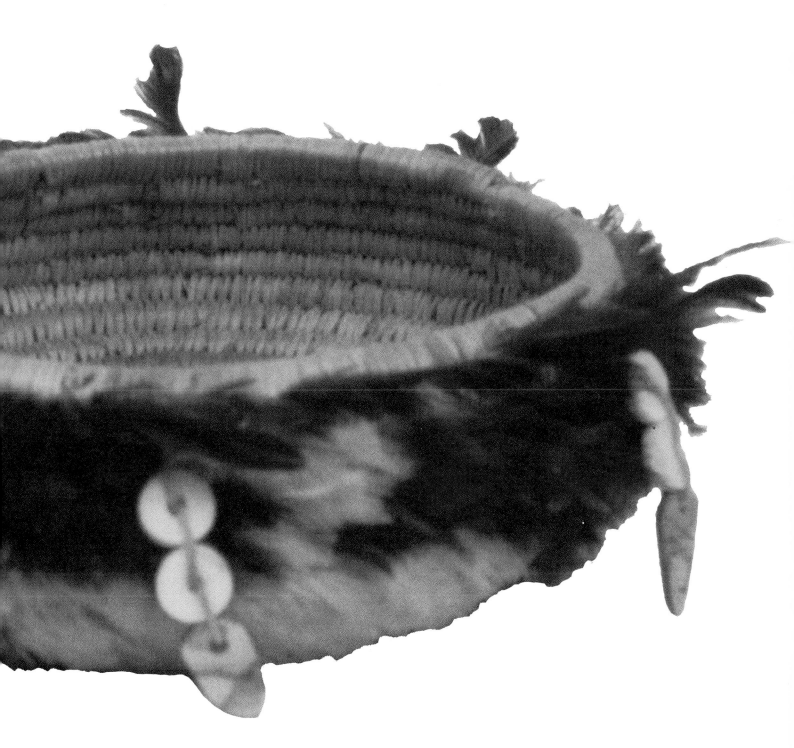

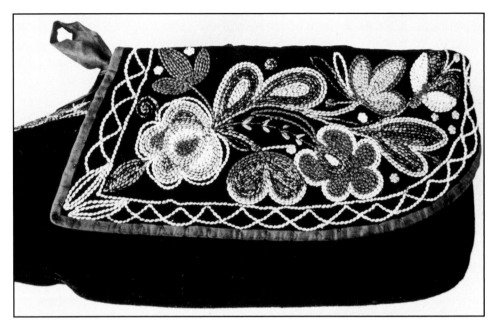

NORTHEAST WOODLANDS

In the past, the Woodland Indians were inspired by the environment that surrounded their towns. There was a symbolic relationship between the clearings where people resided and the woods where the animals and spirits lived. Social and spiritual harmony was maintained by the cooperative balance between these spheres of being. The Woodland people also believed in the duality of the universe, believing people were responsible for maintaining the balance of the universe. This concept can be seen in their art. The use of bilateral symmetry in most native art is a formal way to represent ideas of balance and harmony. This did not mean the decoration had to be a mirror image of itself. Visual balance could also be based upon shape, color, space and symbolism.

The Iroquois Indians of upstate New York became masters of a unique combination of native imagery with European technology acquired after contact. Antler and bone had been ancient artistic materials from which ornaments, tools, utensils and spiritual icons were made. With the introduction of trade goods, such as metal files and saw blades, Iroquoian artists began to make delicate carvings on the mantel of the hair combs. Not only did the European tools allow the Indian artists to make the hair comb thinner, with more teeth, it allowed them an opportunity to make a strong cultural statement through their art. The concept of bilateral symmetry was still evident, yet the use of negative space became more important. Combs

ABOVE
*Black Dyed Moose Skin Shoe*s
Huron, CA 1820
Courtesy the Bata Shoe Museum

took on a new life with the introduction of interesting visual play, such as the representation of the clan or other spiritually significant animals.

Imagery and the exactness of its execution on antler combs also changed with the events of the era. When a horse was first seen in Iroquois country, a hair comb was created showing an exaggerated profile of the horse. Although the animal was not understood within the Iroquois lexicon, it was so impressive the artist used the hair comb to document the horse's arrival in their world.

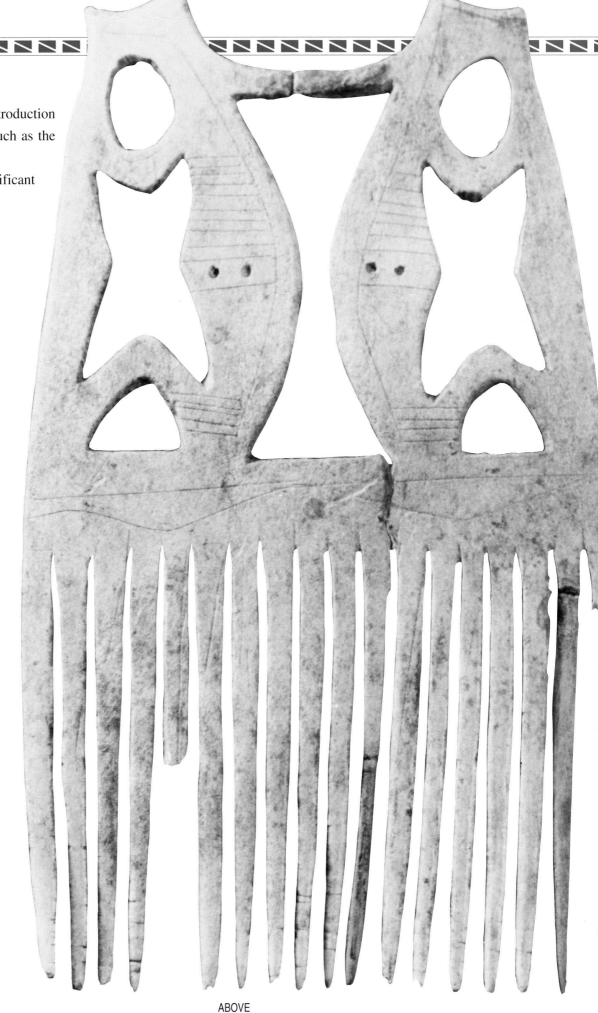

ABOVE
17th Century Iroquois Haircomb from the Rochester Museum.

NORTHWEST COAST

When Spring came,
Leaves grew with a green fresh
feeling,
And the warmth of the sun was
beginning to be felt,
And the animals of the Earth awoke
breathing the fresh new smell.
Of life all over again.

It's like the wind,
Gently blowing,
making love to everything
Before it moves on
Yet returning.

Tlingit Song

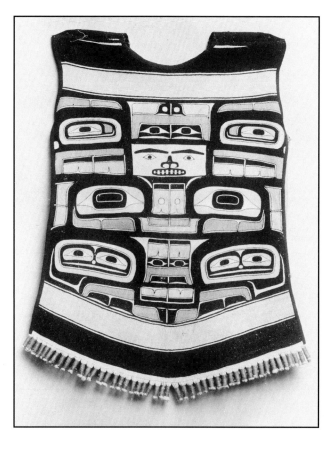

LEFT
Chilkat Tunic
19th Century
Photo courtesy
the Smithsonian Institution

The Northwest Coast combines a unique form of art with grand rituals to keep the oral traditions of the people alive for each generation. Many rituals were a form of theater in which costumed dancers re-enacted symbolic events in the sacred history of the families, clans, communities and the nation. Dance masks, like the Raven mask in this exhibition, are worn on the top of the dancer's head. The beak is operated by strings to make it open and close.

The Raven is a symbolic representation of a cultural hero, one that transforms the environment with wit, wisdom and curiosity. The Raven arranged the Universe, brought sunlight into the world (burning himself black in the process) and finally, uncovered people from within a giant clam shell.

The sea and the lush rain forests of the Northwest Coast region provided the people with great bounty. As a result, there was a very unique system of the arts as a way to exhibit wealth, status and family heritage. The arts were used to retain symbols of the oral history and to record special events in the community. Northwest Coast people had the earliest and strongest art patronage systems in North America. Their clothing, tools, canoes, houses and utensils were elaborately decorated with animal totems of the Eagle, Raven, Bear, Killer Whale, Beaver, Frog, Wolf, Hawk, Dog Shark, Sea Otter and other mythical creatures from the sea. Each tribal group, and each family within the group, had its own unique style of art. Certain designs would be inherited and recycled over the generations.

Among the Northwest Coast people, the totem pole, the world's tallest single piece of wood sculpture, towers above family houses that line the shores of the ocean inlets. These poles were symbols of the cultural identity of those people, illustrating their history and significant sacred events. There are five types of totem poles: memorial poles of family crests and ancestral emblems; mortuary poles as grave posts; house front poles that serve as doorways; house posts inside the houses to represent the clan effigies of the resident family and those sold to visiting sailors.

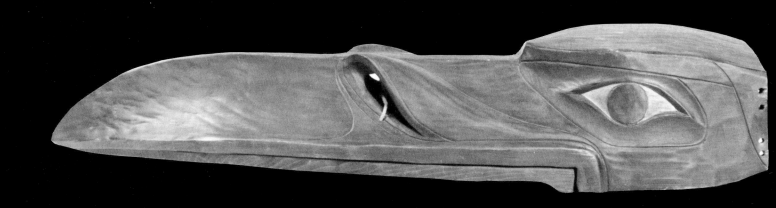

Raven Mask,
Northwest Coast
Painted cedar
7" x 8" x 36"
Acquired: 1971
Edna Massey Collection
IAIA Permanent collection: NW-12

Argillite is a clay like stone that is often referred to as "black slate". It became popular in the development of art for the non-Indian visitor to the Queen Charlotte Islands in British Columbia, one of the few sites where you can find this stone. During the period of increased contact from 1820 to 1900, argillite carvings of pipes, totem poles and plaques evidenced the expert carving skills of the Haida people, who were also known for bold and delicate cedar wood carvings. The argillite carvings were sold to the sailors, traders, foreign visitors and museum collectors. Haida artists also combined European and Victorian era styles and motifs, which became an art form for a new audience. This work features several animals that appear to grow out of each other as if in a process of transformation.

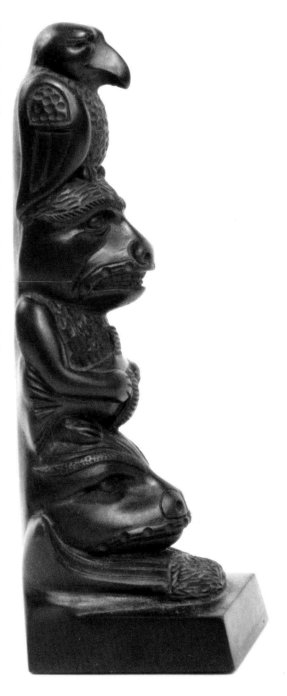

ABOVE
Miniature Totem Pole, Unknown Artist
Canada Collection
Argillite
8-3/8" x 2-3/4" x 3-1/8"
Acquired: 1972
Anonymous gift
IAIA Permanent collection: CAN-3

ALASKA

The lands around my dwelling
are more beautiful
from the day
when it is given me to see
faces I have never seen before.
All is more beautiful,
All is more beautiful,
and life is thankfulness.
These guests of mine
make my house grand.

Inuit Song

The Eskimo (Inuit) world view believes that every object has a living spirit called "inua". These are changing spirits that can appear in human form. The idea of transformation is the core of Alaskan Native beliefs. "Everything is subject to transformation," states Dr. Nancy Zak (Inuit), current Instructor in Cultural studies at IAIA, "nothing is static. Anything or anyone at anytime can change, grow or become."

"People must deal properly and respectfully with animals and objects so as not to upset the inua, and thereby assure that food will be plentiful in the future."

To the Inuit, the Raven is the Creator of things in this world. As Raven approached First Man along the beach, he made things like berries, animals and a woman. A child that resulted from the union of First Man and Woman, began to rip up all the plants Raven had made, so Raven created the bear to protect the plants from the people.

Masks were used in rituals in the hope of a successful hunt by placating the animal spirit before the hunt. Often Eskimo masks of the past used extreme distortion and were said to represent "the fine line between fear and laughter". In this work we see the bear with a fish in mouth emerge from the center of the concentric circles of the mask, surrounded by fish and seals. The bear mask in this exhibition is an excellent example of the Eskimo (Inuit) representation of the inua of the bear. Eskimo masks have a long tradition in the use of exaggerated features of animals as a way to represent spiritual powers.

BELOW
Bear Mask, Unknown Artist
Eskimo
Wood, feathers
18" diameter
Acquired: 1971
IAIA Permanent Collection: ESK-81

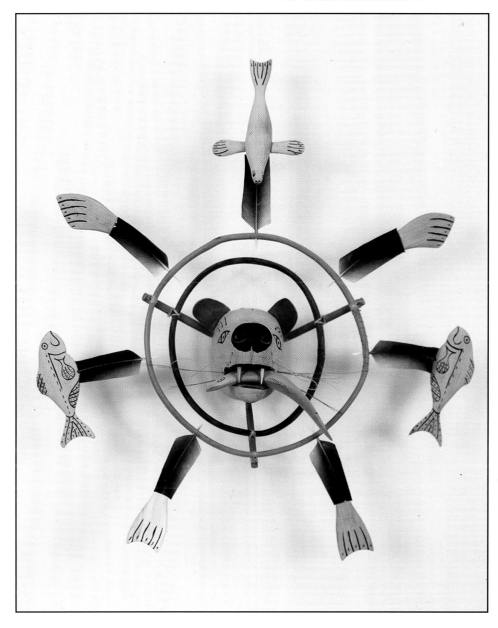

The Tlingit Indians of Southeast Alaska are noted for the "chilkat" style of woven blanket, in a culture more like the Northwest Coast tribes. The art style used in wood carving, painting and clothing decoration is also similar. This weaving is made of cedar bark, mountain goat wool dyed black, yellow and blue, designs handed down over generations. A painted pattern board would be used by the women weavers to copy the design in perfect bilateral symmetry. The work was created on an upright loom, with the fibers attached only at the top. Small sections of the weaving would be made separately and then woven together. These blankets, produced by the Tlingit and Tsimshian Indians have become extremely rare.

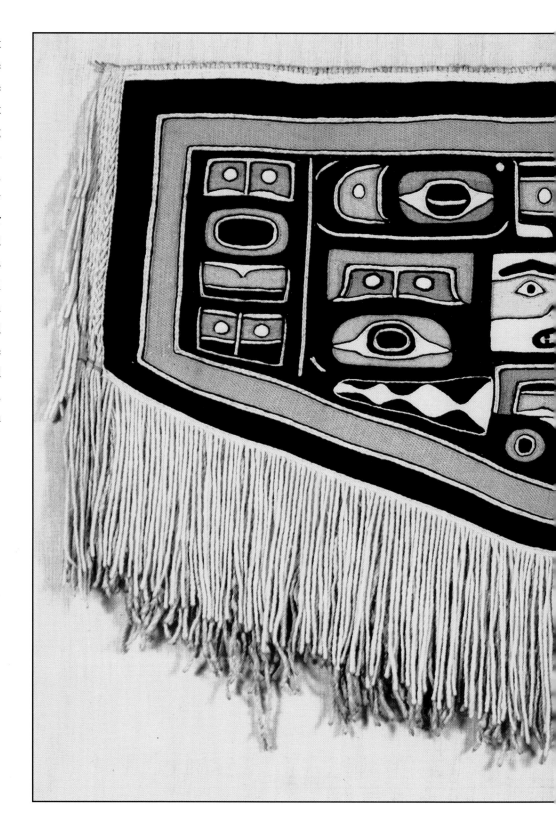

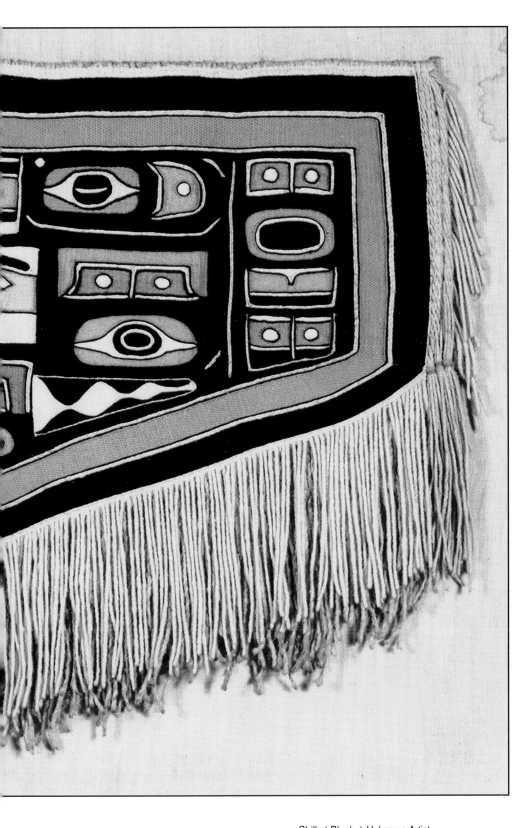

Chilkat Blanket, Unknown Artist
Goat hair, dog hair, bark, natural dyes
43"x 60"
Acquired: 1971
Edna Massey Collection
IAIA Permanent Collection: NW-14

ABOVE
Untitled, Hank Gobin
Snohomish/Tulaip
Watercolor c. 1980

CHAPTER TWO
INDIAN ART IN TRANSITION

Indian art has been in a constant state of transition starting long before the arrival of Columbus.

The underlying premise of Indian art which is often overlooked is one of change. Most Indian art exhibitions have attempted to define change by categorizing a style or specific time period. However, this approach does not recognize a natural, transitional flow in the development of Indian arts, in response to social, cultural and economic change. Indians use the strength of their traditional problem-solving and decision-making skills to reflect on the significance of that change.

There is a misconception that in order for Indian art to be "traditional," it must copy the past. This misconception is evident in the curatorial debate over traditional Indian art versus contemporary Indian art. Traditional Indian art is thought to possess certain design and technical requirements that link it to the past, while contemporary Indian art is thought to be individually directed, breaking tribal design motifs. This approach fails to recognize Indian art as one of constant creativity. Contemporary Indian artists are not challenging past norms, but reaffirming an ongoing belief system that values creative adaptation.

Art is a way to express a people's struggle for cultural survival. Each generation's thinking about the world in which they find themselves is evidenced in the art of that culture. As new materials and new ideas came along, Indian artists reacted to the new stimuli.

Ideas about art, culture, beauty and truth have always been evolving.

By understanding this constant creative transition, we can begin to see that Indian art has always been contemporary to each generation. The art was relevant to the world view of the times. Even though some aspects of Indian art can transcend time and culture, it is the context of the work which gives the art its most potent and influential meaning.

In 1973, Cayuga Chief Jacob Thomas wrote a statement for an exhibition of Iroquois art that embodies Indian thinking about our creative skills.

"As we grow up we are pronounced and called in a particular line. We give thanks to the Creator for our ability and talents which we proudly present to the people – we are never competing. We are showing what human hands may do for our culture as it is the only thing we have left. This is the way we can express our minds to the world today so that our culture may be revived. Now we, the artists and crafts people, proudly present our ability which the Creator has given us. We forever give thanks to our Creator for what we are today." (1)

Tom Huff, a Cayuga sculptor and creative writing student at IAIA, wrote the following poems that explain more directly why the arts are important as a way to express the unique Indian identity and why the Indian students found the program at IAIA so challenging:

UNTITLED

From a blizzard of whiteness
We must emerge
If we are to
survive.

A STRANGE RELATIONSHIP

When carving my stone
The stone laughs at me, taunting
Carve me up, Tom Huff, carve
me up
Smash me with your hammer
and chisel
So I proceed to carve into it until
In a fit of passion, hit a crack
And smash it into a million
pieces
And throw them outside on the ground.
As I walk away
I hear the pieces laughing.

RIGHT
The Dance Continued
1875 Drawing by Making Medicine
Cheyenne prisoner at Ft. Marion, FL
Photo courtesy Bureau of American Ethnology

47

Larry Littlebird ▪▪▪▪▪▪▪▪▪▪▪▪▪▪▪▪▪▪▪▪▪▪▪▪▪▪▪▪▪▪

Storytelling has become the lifeblood of Larry Littlebird, Santo Domingo/Laguna Pueblo. The use of words to express himself can be seen in his work. Littlebird created a series of very lyrical paintings at IAIA as a form of visual storytelling. The works employ layers of meaning and scenes from the stories he learned from his people. He uses poetry, filmmaking, acting and storytelling as a way of teaching Indian knowledge. Littlebird has produced several films such as "Dan Namingha" for the Corporation for Public Broadcasting. "I'd Rather Be Powwowing," for the Buffalo Bill Historical Center in Wyoming and a ten-part film series "The Real People" for KSPS-TV in Spokane, Washington. Littlebird believes stories are sacred, a gift to the people to give them a way to live.

"In tribal American culture, stories stimulate all of the senses, not only the auditory ones, but also the visual" states Littlebird. "And they guide a person in coming into a closer relationship with their surroundings. Storytelling in public has come about mainly through work with children in schools and through a curriculum I developed for the Institute of American Indian Arts called the Storytelling Workshops. Because my stories are specific to me as a human being and where I came from, I can relate what is going on in the story to people who aren't necessarily part of the culture, in a way they can understand and perceive. I consider myself not really a storyteller, but a story listener. Without listeners, there are no real stories." (2)

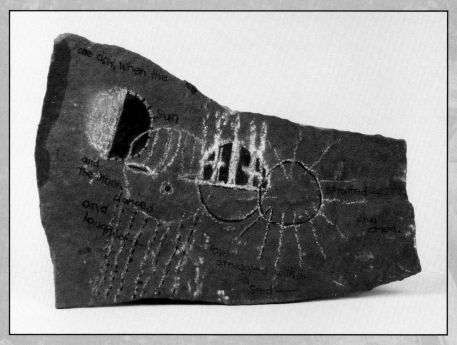

ABOVE:
Modern Rock Pictograph, Larry Littlebird
Santo Domingo Pueblo
Flagstone, paint and chalk
12" x 17-1/2"
Acquired: 1963"
IAIA Permanent Collection: SD-61

Pictographs and petroglyphs abound across the land as one of the oldest forms of expression from Indian artists. Designs, symbols and sacred imagery reflect a visual literacy that existed before the arrival of Columbus. These works evidence belief systems from the past that still have relevance among many native nations of today. Past artists have left visual proof of their beliefs for us to better understand their world view. If we were to apply the same principle to today's artist - a message to future generations - what would the pictographs of today look like?

This is the premise behind work by Larry Littlebird. He paints his message on a slab of rock, just as his ancestors did, but this is his message.

Rose Kerstetter

Some contemporary Indian artists find great satisfaction in evolving ancient forms ... not in an effort to live in the past, but as a way to express respect and affinity for beliefs the older work represent. Kerstetter takes an older Iroquoian form of ceramics, a unique dual rim ceramic jar from the sixteenth century and combines it with stoneware to create a tribute to her ancestors. In such work the artist shows insight and gives respect to the work of the ancient ones, at the same time learning to master the materials used in the past. The bottoms of older Iroquoian pottery are rounded so they can be set in the coals of the fire. They cannot stand on their own.

In the new works by Kerstetter, the bottoms are made flat, so that the work can be free-standing. The artistry is in the execution of the form, following the styles of the past, yet adapting them to the uses of today.

BELOW
Stoneware Iroquoian Vase, Rose Kerstetter
Oneida
Stoneware
9"x 8"
Acquired: 1984
IAIA Permanent Collection: ON-38

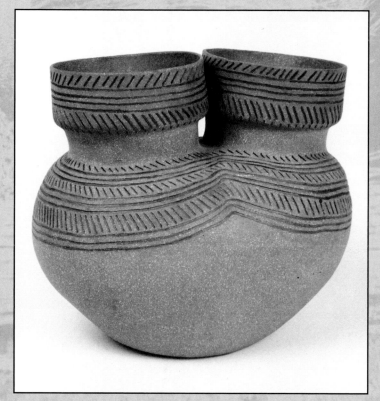

Randy Chitto

For many Indian societies the Turtle is an ancient symbol of long life. It represents the Mother Earth to the Woodland Indians. Some still have a dance to honor the Turtle. Choctaw artist Randy Chitto makes that ancient idea come alive in his work. We see the Turtle acting as a storyteller mother passing on her knowledge.

This work gives shape to the idea the Earth is alive. Although Turtle symbols can be seen in the ancient art of the Southeast, origin of the Choctaw, Chitto now recreates the Turtle and further personifies the oral traditions of his people.

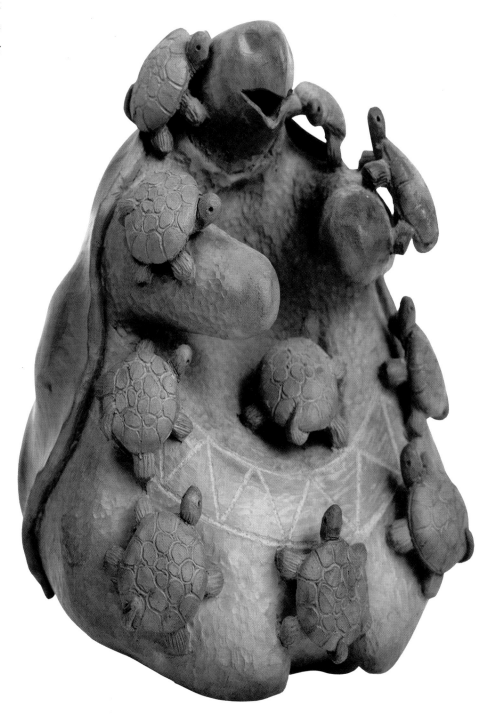

ABOVE
Turtle, Randy Chitto
Choctaw
Clay
10" x 8" x 10"
Acquired: 1987
IAIA Permanent Collection: CHO-10

50

Anthony White

Among the Ojibway people the Bear is a symbol of great spiritual and medicinal power. Artist Anthony White employs the beadwork styles of the Ojibway to decorate his ceramic bowl. He draws from the typical clothing style of his people to create a visual frame of reference, upon which to place the Bear effigy.

While the historic Ojibway may have carved wooden bowls and ladles with images of the Bear, this approach is a simple adaptation of an existing art tradition to create new work which reflects his tribal beliefs.

ABOVE
Ceramic Pot, Anthony White
Ojibway
Stoneware, painted designs
7-1/2" x 13" x 9-1/2"
Acquired: 1983
IAIA Permanent Collection: OJI-9

51

Beadwork is often thought of as a "traditional" Indian art, yet the introduction of beads is a relatively recent innovation, given the 30,000 year history of art by the Indian Nations of North America.

In fact, glass beadwork has been a constantly evolving tradition among Indians since the arrival of European glass beads in the 1550 s.

In Big Bow-Kiowa, Marcus Amerman takes the tradition of beadwork to new levels of expression. Using beads as a medium of image, instead of a simple decorative approach, he created a series of beaded portraits with historic photographs as his models. His beadwork depends upon simplifying shape, color, light and form into basic beaded elements. His skill in using beads to create forms, shadows and a sense of reality is remarkable, representing a new evolution in the use of beads.

Each generation will find new ways to use beads and each beadworker will imprint his or her own identity on the process. This type of innovation can become an important art tradition for Indians when viewed across the generations.

RIGHT
Big Bow - Kiowa, Marcus Amerman
Choctaw
Cut glass beads
6-7/8" x 5"
Acquired: 1986
IAIA Permanent Collection: CHO-76

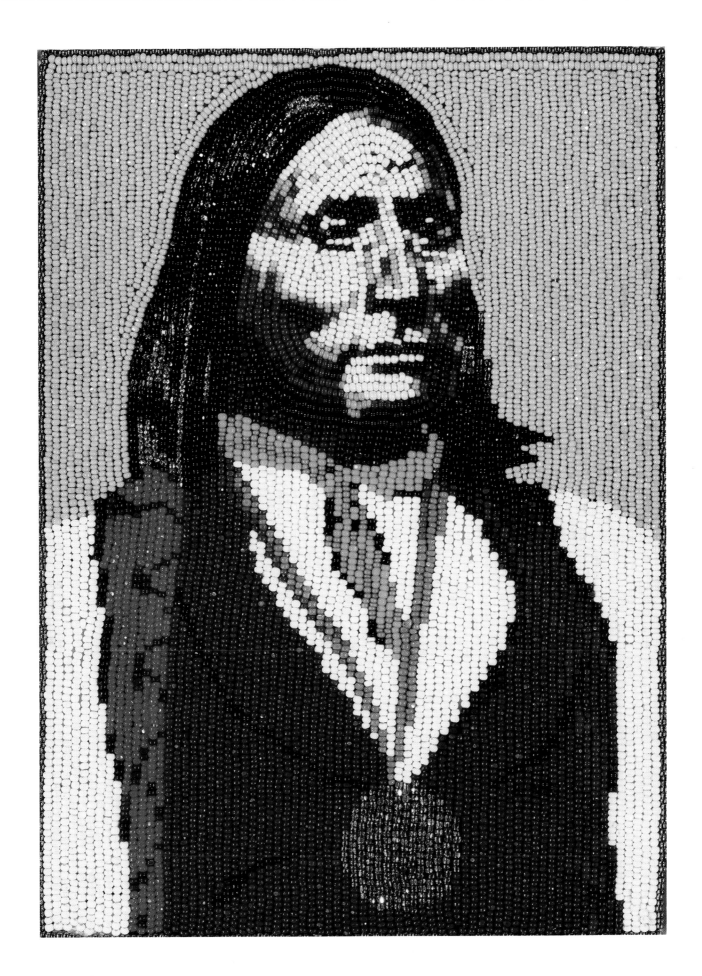

The Coffin Brothers

Barry Coffin, Potowatami/Creek, comes from an artistic family. His two brothers, Doug and Tom, have been in the Santa Fe area for many years, yet each has a distinctive approach to art.

Wally Koshare Meets Rambo, was a gift by the artists to the National Collection of Contemporary Indian Art. It represents the humor and satiric wit that Barry Coffin brings to his art. In this work he combines three cultural icons – the Koshare of the Pueblo Indians, "Rambo" of Hollywood movie fame and the American comedy standard, the rubber chicken.

The Koshare often brings humor to Pueblo ritual and this traditional use of comedy is the inspirational source for Barry's work. Humor plays an important role in Indian culture. Seldom will you find a group of Indians who are not laughing and enjoying funny stories about their ancestors or friends. Barry uses a comic look in most of his work to question the conflicts which exist between cultures and to stimulate debate regarding the social inequities that keep Indians on the edge of the mainstream.

In the cast bronze wind chime entitled, *Another Good Indian,* Barry shows us a dead Indian swinging from a hangman's noose with his tongue hanging from his mouth. Such pieces do not always find a receptive audience, due mainly to people's perception that Indian art is supposed to be happy or spiritual in nature. Barry forces us to confront such notions.

"I feel sorry for people who lack a sense of humor," Barry told newspaper reporter Nancy Gillespie, "They're missing out. I make political statements on how Indians have been treated and the viewers are free to interpret the message however they wish ... but the pieces are done with humor and respect."

Doug Coffin, Barry's brother, has chosen assembled sculpture and painting to make his mark in the Indian art world. Doug takes the idea of combining natural items – wood, bone, hair, fibers – to make an object of power, an idea that has been used for many centuries in Indian societies. By creating his own set of ritual objects that speak to a deeper sense of power and identity, the objects transcend specific tribal identity. They express the core idea of the natural/ritual object, without violating it's spiritual identity.

By drawing from a variety of cultures, Doug shows that ritualized symbols can be found around the globe. People can identify with his work as a metaphor for people connecting to the environment.

Out of this thinking emerged Doug's totem series in which he creates large works of wood and metal that combine shape, color and natural materials in new ways, yet retain a deep sense of purpose.

Doug taught at IAIA, the College of Santa Fe and Fort Wright College in Spokane, Washington. He created, fabricated and erected a 35 foot steel totem as well as several large wood pieces that are geometric in form and painted with bold colors. Circles, arrows and stripes are used as his own form of visual language.

The third of the Coffin brothers to attend IAIA was Tom Coffin. Tom works in bronze and shys away from Indian motifs in his work, wanting to avoid stereotypes altogether. Instead, he reacts to his world, recalling experiences on the road and creating art about the realities of his life. For a while Tom created a series of small dioramas that were three dimensional landscapes within a box. His works are an emotional response to color and craftsmanship. The total visual effect of the sculptures has a sense of whimsy and satire similar to that of his brother Barry and a design sense that is more formal, like his brother Doug.

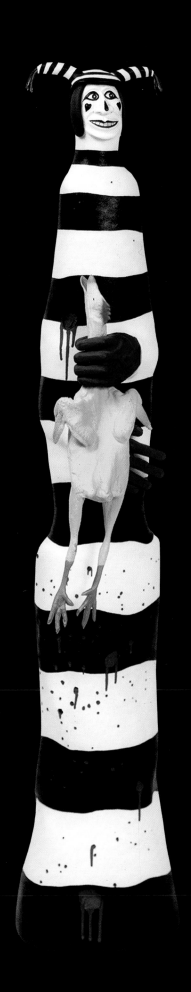

Wally Koshare Meets Rambo, Barry Coffin
Potowatomi/Creek
Painted clay, rubber chicken
54-1/2" x 11-1/4"
Acquired: 1989
IAIA Permanent Collection: PW-14

Doug Crowder

Doug Crowder, a Mississippi Choctaw, was an ardent supporter of IAIA. He produced some of the more challenging ceramic pieces in which scale and image recall a sense of ancient cultures at work. He wrote of why IAIA should exist:

"I know there are relocation and trade schools, but by all means I don't intend to be a factory worker because I can use (my) art talent to be among the leaders instead of being led." (3)

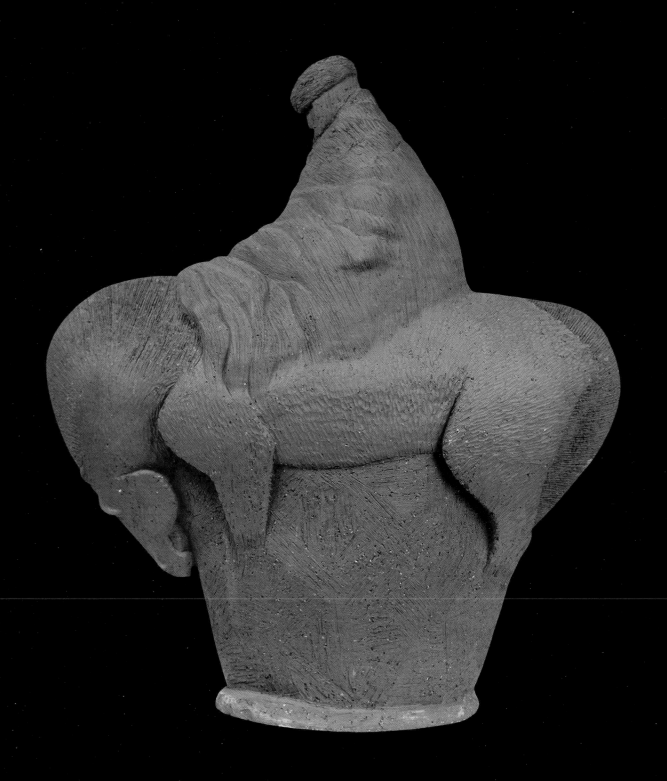

Horse & Rider, Doug Crowder
Choctaw
Low fired clay
28" x 26" x 8-1/2"
Acquired: 1963
IAIA Permanent Collection: CHO-19

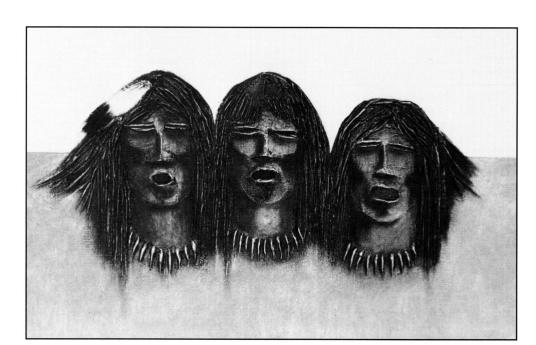

Singers, Phillip Suazo
Pueblo
IAIA Permanent Collection

A New Indian Image Emerges in Painting

Painting by Indians has undergone great change over the last century. The use of paint to express beliefs about nature and identity has a long history in Indian societies.

As an Indian art form, painting has been affected most by new materials, new ideas and new approaches to self-expression. A fine art approach has been adopted over the last five decades, due mainly to increased demand for paintings in exhibitions, museums, publications and as collector items. An emphasis on the personality of the individual has emerged along with the idea that an artist must evolve a unique style to be of significance. Indians who went to art school were taught the concepts of the cutting edge as a way to define fine art.

Artists are measured by formal principles of painting or identified by the style they employ such as surrealism, post-modernism, abstraction, realism or cubism. This method of analysis and categorization may not fully describe contemporary Indian painting. It tends to establish only the mainstream as a measure of success.

Many Indian artists began to experiment in a variety of styles as object lessons. They acknowledged being in search of new ways to present their feelings and emotions about things which are Indian. By extending the flow of paint on canvas, the contemporary Indian painter brought an increased sense of emotional involvement to the process of painting. This emotional intensity combined with the art making process elevated the concept of image-making among Indians to new heights of experimentation. Symbolic imagery, cultural content and individual expression were evenly matched with the process of making art.

Indians have been using Euro-American tools, materials and styles for nearly four hundred years to express what faces them in the real world. Art has played a major role in Indian societies by allowing Native people a chance to assess what is happening to them. Art was made to create a sense of beauty, to confirm beliefs, and to manifest individual thinking about the universe.

Indians create art because it is a human function. Indians make art because they feel compelled to do so. Indians express themselves through art because the social, political and religious education received at the hands of Euro-Americans has not always allowed them to be themselves. Art for Indians is perhaps their last hope to retain individuality in a country that promotes uniformity. Indians create art as an act of defiance to thwart subjugation, to protest assimilation and as an act of faith! Contemporary Indian art says it's okay to be Indian in the modern world. In this way each generation of Indian artists further breaks the superimposed definitions. They appreciate the past, their heritage and their artistic legacy while attempting to move that heritage and legacy into the future. Such effort should not be measured by anthropological or sociological rules. Indian art is self-validating. Each artist has a legitimate life.

NEW WAYS, OLD WAYS

Beauty in the Old Way of life -
The dwellings they decorated so lovely;
A drum, a clear voice singing, And the sound of laughter.

You must want to learn from your mother;
You must listen to old men not quite capable of
becoming white men. The white man is not our father.
While we last, we must die of hunger.
We were a very Indian, strong, competent people;
But the grass had almost stopped its growing,
The horses of our pride were near their end.

Indian cowboys and foremen handled Indian herds.
A cowboy tradition clashed. No one Indian was equipped to
engineer the water.
Another was helpless to unlock the gate.
The union between the hydro-electric plant and Respect for the
wisdom of the long-haired chiefs
Had to blend to build new enterprises By Indian labor.

Those mighty animals graze once more upon the hillside.
At the Fair appear again our ancient
costumes. A full-blood broadcasts through a microphone
planned tribal action.
Hope stirs in the tribe. Drums beat and dancers, old and young,
step forward.

We shall learn these devices of the white man.
We shall handle his tools for ourselves.
We shall master his machinery, his inventions,
his skills, his medicine But we'll retain our beauty
And still be Indian.

Dave Martinez
Navajo, 1965

Bennie Buffalo

Bennie Buffalo was born in Oklahoma in 1948. A Cheyenne Indian, his work has changed from large abstract canvas with broad movements of form and color to works that look like solarized photographs of contemporary Indians. Of his work, Buffalo states:

"From abstraction to realism I am trying to relate my art to free thinking … I attempt to create a synthesis of the pure, unexplainable, abstract thought processes that occur in every mind everyday. The feeling that music can create for the soul, so also does reality award … us the visual stimuli that gave our people beauty." (4)

ABOVE
Red & Blue Blanket On A Pendleton,
Bennie Buffalo
Cheyenne
Acrylic on canvas, with decorated feathers
(restored)
42" x 84"
Acquired: 1968
IAIA Permanent Collection: CHY-5

Ray Winters' *Untitled* is an excellent example of how young Indian artists at IAIA tried to break down stereotypes about how Indians should paint. Many cliched approaches had been adopted by Indians so it was difficult to be creative in your own community. Many had adopted a tradition of romantic realism. Northern Plains painting since the 1900 s was typically scenes of a former lifestyle. It was as if the Indians had to relive their past through such art. The present was not part of the Indian reality. This placed Indians between two worlds: the past where everything was noble and strong and the present where no one wanted to be.

Ray Winters challenged both of those notions with his large canvases in which we see a remnant of the romanticized past, tipis in the golden haze of memory being overshadowed by cubist figures of Indian beings. His use of color and scale to shake up notions of peacefulness reflect his concern that the realities of life be addressed as they exist on the reservation.

BELOW
Untitled, Ray Winters
Sioux
Acrylic on canvas
60-1/2" x 96-1/4"
Acquired in 1969
IAIA Permanent Collection: 1966

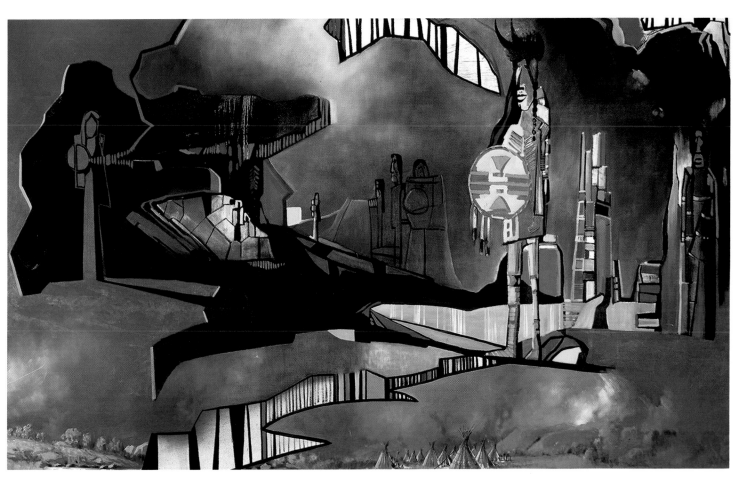

Sherman Chaddlesone

"My primary concerns with the interaction of color and light persist and are evident today as, say, in 1973. Realism, especially photo-realism, has been of great interest to me lately ... but those subliminal nuances which identify my Kiowa psyche will remain in my work."

Sherman Chaddlesone, 1981

The Winter the Sioux Came,
Sherman Chaddlesone
Kiowa
Oil on canvas 34" x 72"-1/2
Acquired: 1967
IAIA Permanent Collection: KI-14

Anthony Gauthier

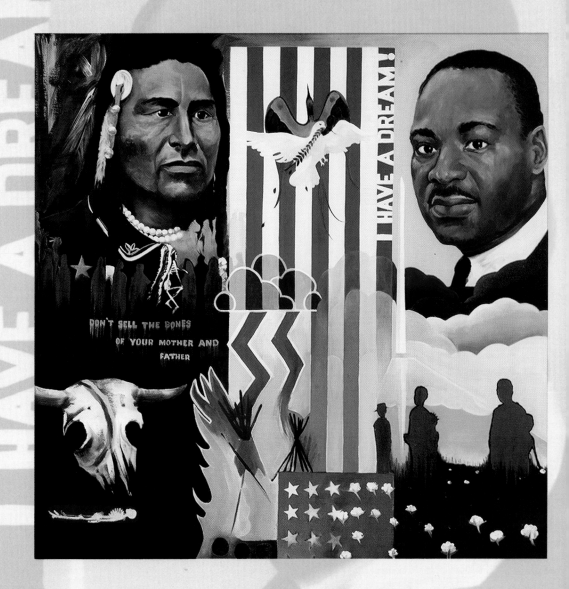

"Art can be used to bring Indian students around to be proud and strong. It can be used to avoid being eased into accepting the American Dream, and going to war … There are so many books that tell of the defeat of the American Indian. This creates a bad feeling, that we lost all our wars, pushed everywhere. Where is the joy? We have been spoonfed for so long and have had the flag waved in our faces so long. We can no longer think as we should as Indians.

We have become complacent. We lack unity … Chief Joseph had to make decisions for his people. He remembered what his ancestors told him – 'Don't sell the bones of your ancestors.' His flight represents his struggle to make sure his people lived another day in freedom. We need more leaders like him." (5)

ABOVE
Bicentennial Painting,
Anthony Gauthier
Menominee/Winnebago
Acrylic on canvas
Acquired: 1976
IAIA Permanent Collection: WIN-14

63

Portfolio

RIGHT
Ceramic Vase, Mike McCabe
Navajo
Raku fired clay
9" x 6" x 5-3/4"
Acquired: 1985
IAIA Permanent Collection: N-584

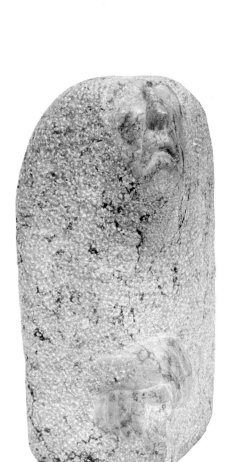

LEFT
Humble Face & Hands, Don Chunestudy
Cherokee
Alabaster
17" x 8-1/4" x 8"
Acquired: 1971
IAIA Permanent Collection: CHE-8

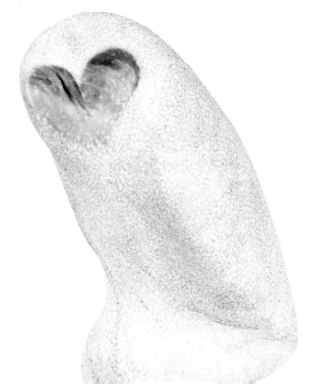

RIGHT
Owl, Robert Shorty
Navajo
Alabaster
13-1/2" x 10" x 7-1/2"
Acquired: 1967
IAIA Permanent Collection: N-334

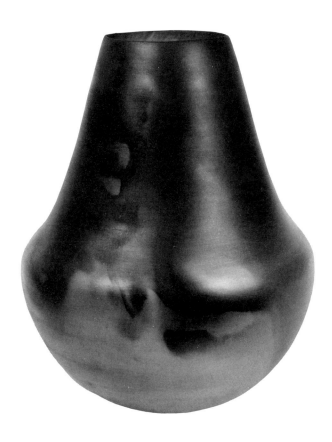

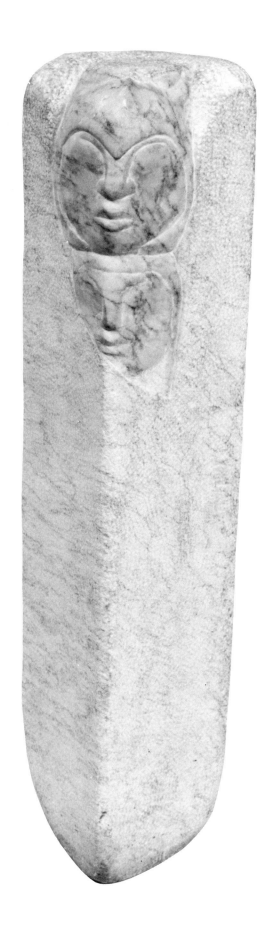

ABOVE
Vase, Jacquie Stevens
Winnebago
Clay
14-3/4" x 13-1/2"
Acquired: 1985
IAIA Permanent Collection: WIN-252

RIGHT
Faces, Don Chunestudy
Cherokee
Alabaster
30" x 6" x 6"
Acquired: 1968
IAIA Permanent Collection: CHE-29

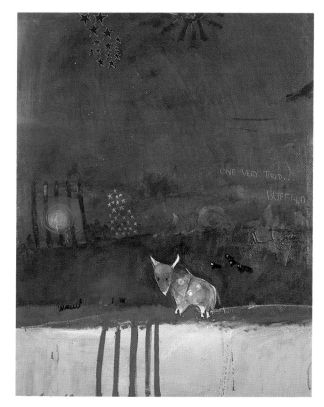

ABOVE LEFT
Untitled, Charlene Teters
Spokane
Oil on canvas
24" x 30"
Acquired 1986
IAIA Permanent Collection: SPK-46

LEFT
Kicking Bear, John Fox
Potowatomi
Oil on canvas
57-1/4" x 46"
Acquired: 1986
IAIA Permanent Collection: PW-18

ABOVE
Tired Buffalo, Randy Sahmie
Hopi
Oil on canvas
50" x 40"
Acquired 1969
IAIA Permanent Collection: H-33

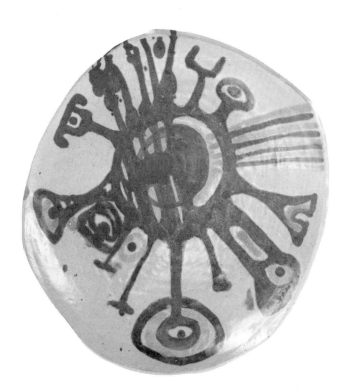

 ABOVE
Awaiting the Muse, Luke Simon
Micmac
Acrylic on masonite
54-1/8" x 41"
Acquired: 1982
IAIA Permanent Collection: MI-4

ABOVE RIGHT
Ceramic Plate, Christine Nofchissy
Navajo
Ceramic
11-1/2" diameter
Acquired: 1968
IAIA Permanent Collection: N-366

RIGHT BOTTOM
Athapaskan Descent, David Draper
Navajo
Ceramic sculpture
13-5/8" x 12-1/2" x 7-1/8"
Acquired: 1987
IAIA Permanent Collection: N-179

"I don't like the term Indian art. I am an Indian who happened to choose art as a way of life. It suits the way I live and it allows me to be the kind of person I want to be. I work in clay because I like the immediacy of the material. It takes me from five to fourteen hours to complete a piece. I work directly with the material without sketches. I let the clay react to my direction. I want the finished piece to look like clay. My subject matter is usually about my people or of people who may affect my people. I believe that my people are natural beings and that they do not need to be romanticized as stoic, red, colorful, cultural oddities in 20th century America by art or artists ..." (1)

Peter Jones, Onondaga
IAIA Alumnus, 1963-65

Instructors at IAIA circa 1967

CHAPTER THREE
THE IAIA EXPERIMENT IN THE ARTS

In 1962 a unique experiment in Indian education was undertaken by the Bureau of Indian Affairs (BIA). A century of denying the value of Indian art in education was reversed with the establishment of the Institute of American Indian Arts in Santa Fe, New Mexico. It began as an Indian high school dedicated to the development of the arts. The objectives of the experiment have evolved over time with the Institute still growing and changing three decades later.

The thinking that gave birth to IAIA was a combination of evolving social attitudes toward Indians, changing federal politics and a social renewal among Indians who had suffered a generation of relocation and assimilation.

With the introduction of new materials and a new spirit, the Indian artist could experience a true renaissance. The 1961 BIA information bulletin stressed providing new doors of opportunity for Indian self-expression in the arts. Now the arts would be used to provide educational and employment opportunities.

Indian Artists Light the Creative Fire as Instructors

In their own right IAIA Instructors made significant contributions to the development of contemporary art by Indians. Imagine what Indian art would be without the works of Larry Avakana, Louis Ballard, David Bradley, George Burdeau, Karita Coffey, Grey Cohoe, Keith Conway, Larry DesJarlais,

Preston Duwyenie, Henry Gobin, Joy Harjo, Allan Houser, John Hoover, Doug Hyde, Rosalie Jones, Linda Lomahaftewa, Charles Loloma, Otellie Loloma, Manuelita Lovato, Phil Lucas, Simon Ortiz, Ted Palmateer, Neil Parsons, Diane Reyna, Fritz Scholder, Ed Wapp and Josephine Wapp. They, along with many dedicated non-Indian faculty members, created a positive climate for change.

In three decades of art education IAIA has seen nearly three thousand students pass through its studios and classrooms. The impact of IAIA is just beginning to be understood as the second generation of students (children of the alumni) are now attending IAIA. There is no other model like IAIA. This Institution has influenced the majority of artists who are now leaders of the contemporary Indian art movement. IAIA has helped to educate many of America's most creative Indian and Alaska Native artists through instruction in the visual arts, the performing arts, creative writing and museum studies.

Changing Themes in Indian Art

Much of the new style of art was developed in reaction to older traditional forms. Indian artists were expected to paint a certain way, without regard for their tribal affiliation or personal experiences. Allan Houser fought against the mold as did several others in the early 1940 s and 1950 s.

IAIA encouraged experimentation. New themes that emerged in the art of IAIA included the Indian Warrior as hero; the spirit within; new interpretations of ancient symbols and cross-cultural images.

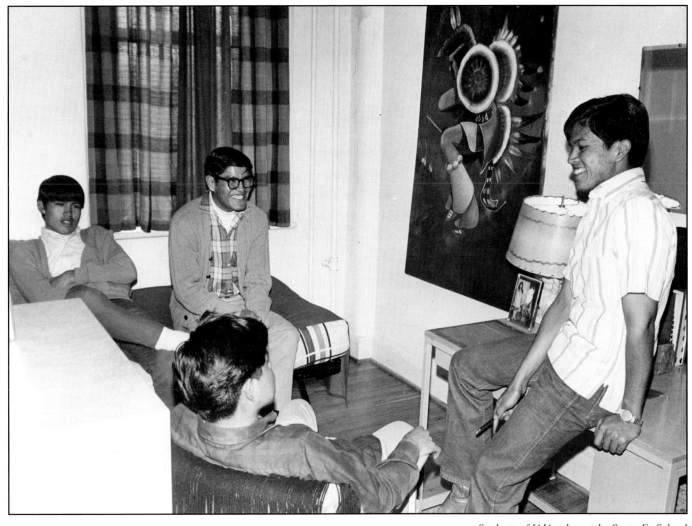

Students of IAIA relax at the Santa Fe School

Merle Thunderhawk

THE RETURN OF THE WARRIOR AS HERO

In contrast to negative stereotypes, a new approach to depicting Indians as heroic spiritual beings emerged. The art of Indians began to reflect a larger social movement for Indian rights and an internal movement of cultural renewal was born. The art began to take on bold new images of Indianness. Art became an act of the modern day artist/warrior.

Many young artists at IAIA saw themselves as warriors of their generation, charged with defending the traditions and beliefs of their people. Their duty was to explore the significance of the tribal way of thinking and adapt tribal designs to represent their new found identity.

This work by Merle Thunderhawk demonstrates the need of this generation to identify with Indian Warrior heroes of the past. The Warrior was a natural connection for a generation that grew up under government policies of assimilation, relocation and dispossession. Since they felt a need to express a fighting spirit, art was their chosen medium of defense.

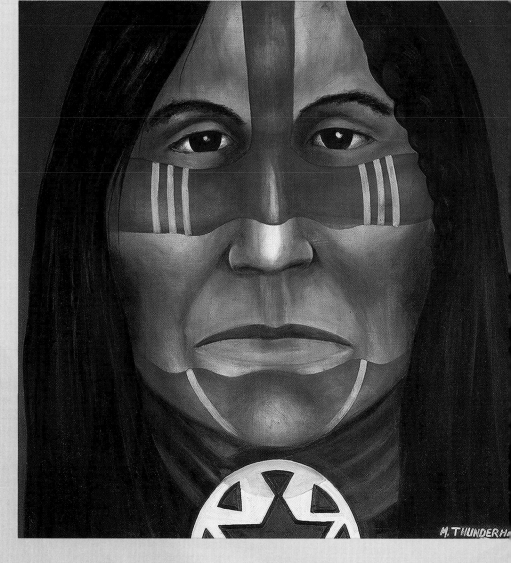

RIGHT
Painted Lakota Warrior, Merle Thunderhawk
Sioux
Oil
50" x 50"
Acquired: 1969
IAIA Permanent Collection: S-075

Phyllis Fife

THE SPIRIT WITHIN

Other young Indian artists adopted new forms of expression, like abstraction and the use of non-figurative painting to express the significance of Indian ways. By studying European and American art, the students at IAIA became aware of other approaches to creativity that could be incorporated and manipulated to meet their personal needs.

Although much of this new style of work was produced as classroom assignments, students still sought cultural relativity. They found they could create work which represented the power of the spirit within ritual objects.

"I like to paint massive, non-objective paintings on canvas. I draw with paint otherwise. I draw with all the immediate energy that I have. To cover the paper with charcoal is literally to cover myself with the dust."

Phyllis Fife

ABOVE
Untitled, Phyllis Fife
Creek
Oil/Multi-media
41-1/4" x 36"
Acquired: 1967
IAIA Permanent Collection: CK-20

Earl Biss

Earl Biss, a Crow Indian, born in Renton, Washington in 1947, studied jewelry at IAIA He planned to make a living as a jeweler. His time at IAIA allowed him to experiment in the other fine arts. He created a series of circular paintings using free-flowing movement and color in an attempt to illustrate what spiritual forces look like through the eye of an Indian. Like dreamscapes from the soul, the paintings give a sense of the power of the life forces in the Crow universe. They represent shields for the modern warrior/artist. Older Plains Indian shields often were decorated with symbols of power that the artist or owner received through dreams and visions. Biss created the same kind of designs, only he removed the outer layer of the symbol and looked deeper into the substance of that symbol. In this way, his work is a window into the Indian conscience, but it is also a window by which the artist can be removed from daily life to other worlds and other times.

Biss felt his work was not about Indians, but about his feelings toward Indians.

"I feel that the inborn flair for art is due to my Indian background. I believe that my sense of balance and color was passed down by my ancestors and this sense cannot be lost, even though tradition is not portrayed in my work.

Color and design are determined by my response to actual process – application, spontaneity and rhythm. The process in itself is the completed piece of the product. I do not restrict my works to outward imagery, but try to capture or illustrate those powers or forces of nature which play such an important part in reality. These are in many ways realistic paintings … and, therefore, though my painting is not materially related to Indian tradition, it is still basically Indian art." (2)

In 1972, Biss had a solo exhibition at the Museum of the Plains Indian in Browning, Montana. At that time, his work was broad ribbons of color that symbolized the landscape. Biss stated that his interest was in representing the harmony of people and nature by combining rigid lines with free-flowing color that looked more like seascapes than landforms. "I am not concerned with capturing the outward image of nature," stated Biss in the exhibition brochure," but rather those powers or forces of nature which play such an important part or basis for the way things are. A concept of reality drawn from spontaneous abstractions, and controlled with the subtlety I wield as the creator." (3)

Biss spent a year in Europe in 1974 and he feels the experience of seeing the European masters changed his art direction. The translucent power of the skies in the landscape painting of Turner, the impressionistic brush work

of Monet, the emotionally challenging images of Edward Munch, contrasted with the garish color schemes of the Fauve Movement can all be seen in his work. He also drew upon the "action" painters of the late fifties to create a style of work for which he has become well known.

He has expressed a concern for the quality of paint as a way to create a mood in the viewer, as compared to the cultural message of the work. That spontaneity produced his best work. Biss pushed color around the surface of the canvas, finding ways to add depth, movement and power to the paint. He admits "juggling the canvas, turning sideways and upside down, letting gravity move the paint, often splashing solvents on the surface, rubbing a rag back to the white surface. It's not unusual for the painting to change several times before completion." (4)

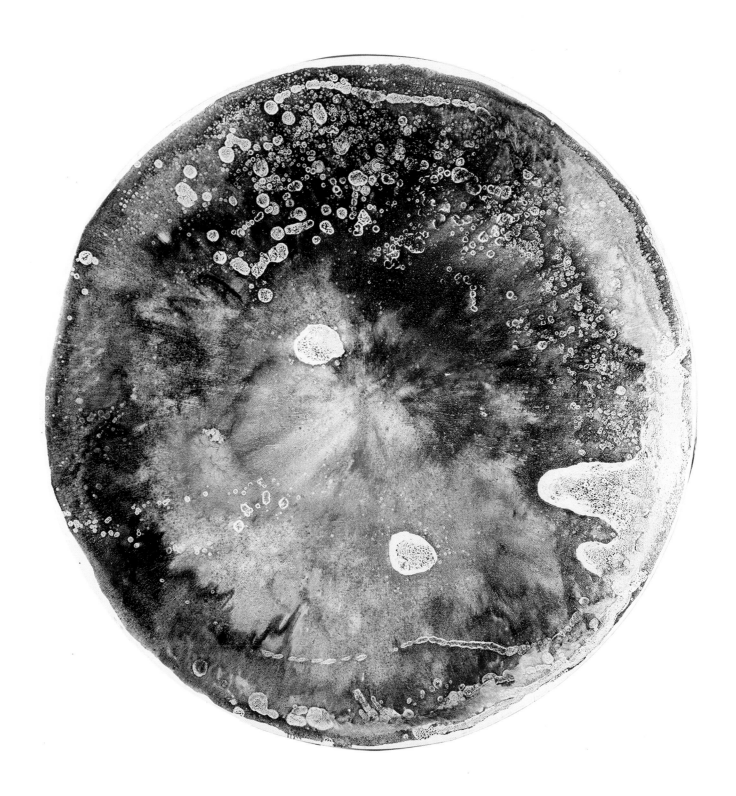

"I am alone, and in this way I find
meaning. I believe an artist goes
through various stages.
I am constantly changing in
my directions and each new step
is like a new day."

Earl Biss, 1967

Ted Palmateer

NEW VIEWS OF OLD SYMBOLS

Many of the IAIA students were encouraged to look at the traditional art of their own tribe and make new interpretations.

In this welded metal sculpture Ted Palmateer personifies the wind spirit commonly seen in Indian cultures. He brings a bit of satire to the sculpture by adding a cowboy hat to modernize the spirit, reminding us the wind spirit is still here. The flowing hair of the man-spirit contrasts with the feel of the hat as his head leans into the wind. Yet the face of the man spirit looks like a skull, conjuring up an image of fear and death. *The Scotsman* reviewed this piece during the 1966 Edinburgh Festival calling it "fearsome and pitiful at once."

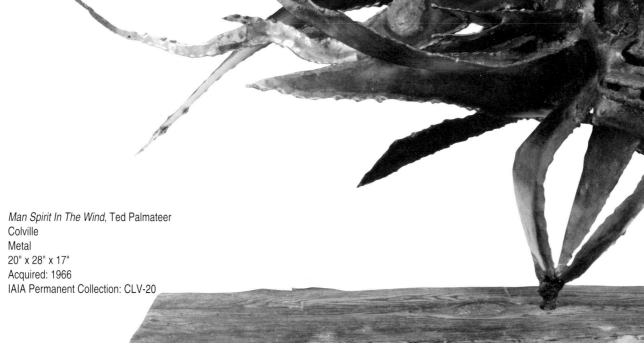

Man Spirit In The Wind, Ted Palmateer
Colville
Metal
20" x 28" x 17"
Acquired: 1966
IAIA Permanent Collection: CLV-20

RIGHT
War Shield, Earl Eder
Sioux
Oil and Acrylic
56" x 61-1/2"
Acquired: 1964
IAIA Permanent Collection: S-090

Earl Eder, born in Poplar, Montana in 1944, is an Oglala and Yankton Sioux Indian who explored directly the historic art of his people. His work was based upon the oral history he had heard as a child, incorporating the rich visual tradition of the Plains Indian. Though many of the Sioux storytellers, who used their native tongue and sign language to tell the stories have passed on, their memories are still felt in the rolling hills and prairie grasses of his homeland.

Eder believes his role as an artist is to represent the spirit of those stories, and not to depict them with precise detail or realism. Expert in both painting and sculpture, Earl Eder made a series of paintings inspired by the tipi paintings and pictographic imagery used by the Sioux of a century before. In War Shield, he recalls the sun circle that can be seen on older buffalo robes. The feathered circle represents the sun shining upon the plains, with penciled buffaloes running across the horizon line. The use of feathers in works of art generated quite a controversy on the IAIA campus as some of the traditionalists felt it was not appropriate to use real feathers. Some Pueblo critics

used the fact that students incorporated sacred eagle feathers in their secular art as an example of how distorted the cultural education was at IAIA. Eder's work used imitation eagle feathers, which have been restored for this exhibition.

Eder, who went on to receive his B.F.A. from the San Francisco Art Institute in 1971, said, "When I paint I become a spirit. I've been exposed to many different medias and environmental changes … which have affected my work and I am compelled to express … I draw from the traditional and ethnic background of my own tribe and others."

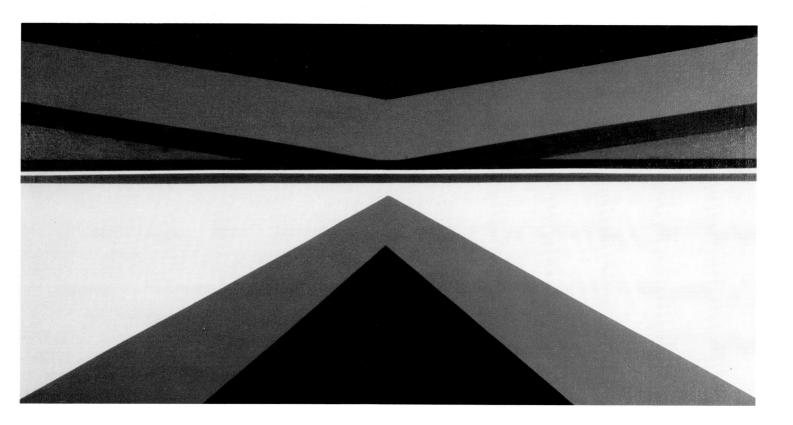

The Plains Indians had a long tradition in the use of geometric designs and patterns in their art. Many examples of Plains Indian painting, quillwork, beadwork and decorative motifs illustrate how each tribal group had a distinctive geometric style.

IAIA student, Carl Tubby, would examine the historic works and rework the design on canvas, often blowing up the dimension, adding vibrant colors and reflecting the sense of space, line and shape applied by the Plains Indian artists.

ABOVE
Crow Stripe Series 4, Carl Tubby
Choctaw
Acrylic on canvas
18" x 36"
Acquired: 1967
IAIA Permanent Collection: CHO-006

RIGHT
Ojibway Spirit, David Montana
To hono O' odam
Oil on canvas
36" x 48"
Acquired: 1967
IAIA Permanent Collection: PA-11

CROSS CULTURAL INFLUENCES

Students at IAIA were exposed to many artistic influences, Indian as well as non-Indian. Art history classes brought them in touch with tribal art styles and indigenous art forms. Euro-American art history and European art history was studied as well. The result of all this was a variety of unique cross-cultural experiments and exchanges that created new avenues for expressing the soul of the Indian artist. A 1967 article in *Life* magazine noted this new approach:

"In the painting classes, students who have barely been exposed to the Western tradition of realistic representation turn out to be naturally gifted abstractionists. This is hardly surprising, considering that Indians have a centuries-old tradition of geometric art. What is surprising is how rapidly Indian students apply their hereditary talents for abstraction to advanced, hard-edged styles." (5)

Artists influenced each other at IAIA as they learned one anothers oral history and artistic traditions. They began to explore imagery from other regions of the country finding a personal affinity with the imagery. In this work by David Montana, Ojibway, Misshepezhieu, (a mythical panther spirit) is depicted, using a photograph taken of a petroglyph located in Ontario, Canada. Montana created a series of works presenting his interpretation of the spirit figure.

Although this kind of exchange was encouraged, some felt uncomfortable in this inter-tribal borrowing. Such appropriation between tribal artists is still a cultural issue.

Doug Hyde ▰▰▰▰▰▰▰▰▰▰▰▰▰▰▰▰▰▰▰▰▰▰▰▰▰▰▰▰▰▰▰▰▰

Doug Hyde, born in Oregon in 1946, came to IAIA in 1963 to study sculpture under Allan Houser. He returned to IAIA in 1971 after a tour of duty in Vietnam and a year at the Nez Perce reservation in Idaho. Houser was impressed with Hyde. He wrote in 1971, "A very creative person is Doug, with a storehouse of energy as well as sculptural ideas to produce." (6)

Hyde's work was very organic, with images of faces, feathers, birds and clothing conforming to the natural shape of the stone. His people appeared to be spirits emerging from the stone. Of his early work, like the piece shown here, Hyde combined paint and wood or stone. "I use paint on a lot of my work and have been asked why I don't just paint. Stone can be touched, there is a real physical contact with the subject. The paint and the beadwork add more character to my sculpture. Each piece is a separate person, an individual that has its own moods. The color helps express the pride or pain built into each of them.

"I work directly on most of my people (sculptures) and try never to use pre-planned ideas. Color and texture are very important. I have been using the past for most of my pieces. My work is moving toward the contemporary social life and pressures of my people. I admire the Mexican artists like Orozco and Rivera." (7)

ABOVE
Sun & Moon Gods, Doug Hyde
Nez Perce
Nails, staples on wood
43-1/2" x 12" x 7"
Acquired: 1967
IAIA Permanent Collection:
NP-005

ABOVE
Porcupine, Sam Sandoval
Navajo
Nails, wood
9" x 10-1/2" x 4-1/2"
Acquired 1968
IAIA Permanent Collection: N:-121

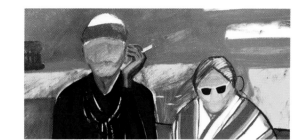

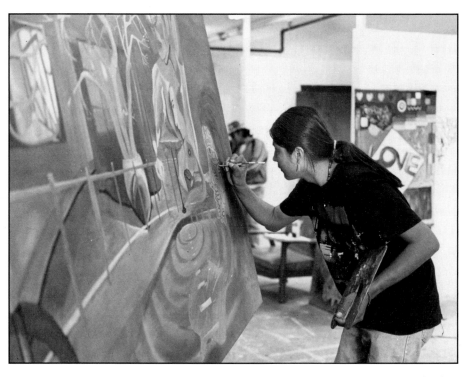

IAIA Painting Studio

CHAPTER FOUR
THE INNOVATORS

Who defines mastery in the arts for Indians? Who are the modern masters of Indian art? The quest to define the best in the arts has been undertaken by archaeologists, anthropologists, ethnologists, historians and entrepreneurs. Indian art has been defined by standards set by scholars, dealers and collectors. In general, Indians have not considered their important works of art. Since very little has been written by Indians about their art, it is difficult to understand Indian art through Indian eyes.

Most of the works in this exhibition were created by Indian students while at IAIA. Although student work often gets dismissed as immature and many are not considered master works, they represent significant innovation in the visual art of Indians.

Art by Indians is an expression of being Indian. It is not based solely in the excellence of the finished work. Art is one way to provide future generations with evidence of today's Indian thinking. Dan Namingha explains the role of contemporary Indian art in this way:

"It used to bother me when people labeled me an "Indian artist." But now it doesn't. I know who I am. People always try to put you into little corners, but if you don't let them, they can't get away with it. An artist should not be limited. In fact, that is one of the reasons why you become an artist – to have freedom to follow your ideas in whatever direction they lead... If there is value to my work, it is that I am helping my heritage to survive, not only among my people, but among all people who understand and appreciate beauty." (1) The following pages present the work of the leading contemporary Indian art innovators and how they view themselves as artists.

84

Delmar Boni

Delmar Boni, one of the most creative artists at IAIA, combines humor and irony along with symbolic imagery. His art calls into question preconceived ideas about Indian art. He came to IAIA in 1974 after attending college and teaching art in Arizona. Boni feels his work speaks for itself, representing both points of view – Anglo and Indian. The Great Native Dream was especially important to Boni in defining what was happening to Indians during the time he was at IAIA. He saw Indians as chasing the Great American Dream, a dream in which they would never be able to participate. That dream is symbolized in the thoughts of the ice cream cone. No matter how Indians dressed, acted or tried to live like white people, they would always be Indians. The lipstick symbolizes the act of trying to look different or pretend you are someone else. The Indians cannot hide behind sunglasses.

Boni decided to return to his reservation and use art as a form of cultural therapy and personal healing.

The Great Native Dream, Delmar Boni
Apache
Acrylic, on canvas
84" x 56-1/4"
Acquired: 1975
IAIA Permanent Collection: A-124

Alfred Young Man

"As for my art, I didn't know where I was coming from in terms of my Indianness. While it naturally reflects the experiences I have lived and the exposure I have to non-Indian ideas and technology, no one can take away the increased respect I have gained for my own cultural background, a respect that was originally instilled in me as a child back home on the reservation by my aunts and uncles Indian beliefs, feelings, that are not only hard to explain but, I believe, beyond a certain point, shouldn't be explained. And while there are certain things Indian that I will never reveal through my paintings, I feel that my statements are Indian; while they are not like those of older Indians they are as real and honest a reflection of me as an Indian in my time as they were of them in their time." (2)

Alfred Young Man produced some of his most powerful paintings as a student at IAIA. The work challenged people's thinking about Indians and race relations in general. Further, it calls into question the disparity between Indian images of the past and Young Man's portrayal of Indian life now.

The IAIA Museum has several large canvases by Young Man including *Bird, Rabbit and Man*, a work that suggests the unity of people with animals and the tendency of outsiders to classify Indians as part of a natural history museum culture, as if Indians are objects of study.

In another work, *3 Different Colored Men*, Young Man uses his humor to present a portrait of three nineteenth century white men with their faces painted red, purple and green, calling to task racial stereotyping, "Native American art," stated Young Man, "is that art which is diametrically opposed to the current western tradition of thinking. Native American art is, therefore, found wherever there is an absence of western thought, and deals in a much more positive manner with the total human spirit in a natural context." (3)

BELOW
Three Creeks, a Ute and a Negro, Alfred Young Man
Cree
Oil and acrylic
48" x 72"
Acquired: 1968
IAIA Permanent Collection: CE-18

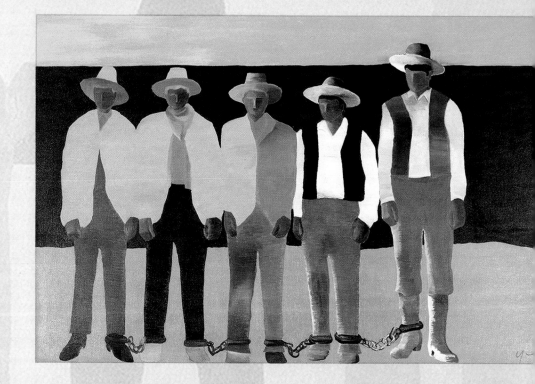

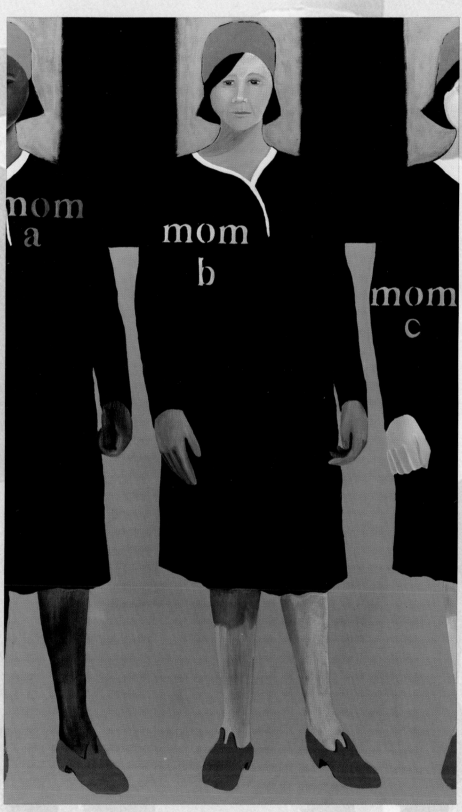

ABOVE
I'd Love My Mother if She Was Black,
Brown or White, Alfred Young Man
Cree
Oil and acrylic
69" x 41-1/2"
Acquired: 1968
IAIA Permanent Collection: CE-15

T.C. Cannon

Tommy Wayne Cannon, a Caddo/ Kiowa whose Indian name, Pai-Doung-U-Day (One Who Stands in the Sun) is perhaps the best known of the IAIA graduates. His early fame was tragically cut short by a fatal car accident. Cannon, along with the others at IAIA, created an art movement of their own in which Indians reclaimed their art, taking it out of the hands of the anthropologists and art dealers. In his work Cannon explored the everyday life of Indians, both past and present. His work was an emotional response to Indian history portraying the historical conflict of cultures in America. This could best be seen in his 1977 twenty-foot mural, "Epic in Plains History, Mother Earth, Father Sky and the Children Themselves." This work was partly created as a special commission for the Daybreak Star Cultural Center in Seattle, Washington. In this piece Cannon traces the Plains Indians through time and marks the significant aspects of Plains Indian beliefs. As if to identify with those beliefs and to show that they still continue, Cannon marked the center of the canvas with his own hand prints in red and yellow.

One of Cannon's works, *Collector #5*, has become a hallmark of contemporary Indian art. In this work, a poster image for an exhibition at the Wheelwright Museum in 1976, we see a prideful Indian in a traditional dress, not unlike the early photographs of oil-rich Osage Indians in Oklahoma. The figure is seated in a wicker chair in front of a

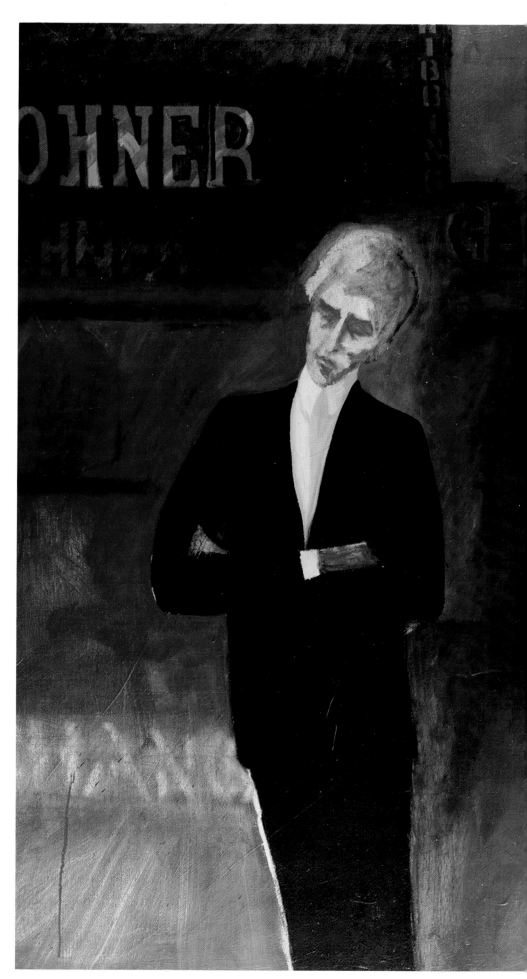

Van Gogh painting, framed by two large windows that look out upon a New Mexico storm. The image of the Indian as a collector of Van Gogh may strike us as funny, but upon reflection, that is just what the Indian artists in Santa Fe have become. They still dress like Indians, feel like Indians and think like Indians, but they have developed a taste for other things, other arts. The piece causes the viewer to ask, why is it normal for non-Indians to collect Indian art, but strange for Indians to collect non-Indian art? It is interesting to compare this work with another Cannon painting, titled, *Self Portrait with Van Gogh* in which we see the expressionless artist in contemporary Indian dress – red shirt, cowboy hat, sandcast buckle and sunglasses, standing in front of a Van Gogh painting, as if it were his own accomplishment.

LEFT
It's Alright Ma, I'm Only Singing, T.C. Cannon
Caddo/Kiowa
46" x 50"
IAIA Museum Collection: CD-13

self portrait in studio

wondering
whether to leave
or stay a bit longer
should i stay the night and paint the
purple
out of that canyon?
or maybe add some political ague to that
dancer 's face wasn't that a great river i
saw this morning? wish
i knew someone important or holy to
share it with
maybe that transient lady with the green
shoes
from california. she is a nice american ...
what with her great breasts and small
mouth
shit, i hope that my spirit is stronger than
that purple
corner over there. if elizabeth was here i
wouldn' t
be so afraid of it all.
enough of this hyperbole and reverie
all the lies were worth this moment
the darkness worth the light
the comedy worth the solemnity

T.C. Cannon, 14 May 76

Mama and Papa Have the Going Home to Shiprock Blues is by far one of the most famous and widely published works in the National Collection of Contemporary Indian Art. It was featured in an exhibition of Cannon and Fritz Scholder's work at the National Gallery of Art in Washington, DC. In the catalog for that exhibition, Robert Ewing, then Director of the New Mexico Museum of Fine Art, referred to this work as the Les Demoiselles D' Avignon of the Indian art movement. Ewing felt that this work was a breakthrough in the creation of the pop Indian art style, incorporating multi-images and words. Cannon's friends who worked with him at IAIA remembered the painting as being unfinished.

Often, during the first years of IAIA, art works would be taken from the students and retained by the Museum collection. Bill Soza and Alfred Young Man recalled how Cannon said this work was removed from the studio before it was finished.

RIGHT
Mama & Papa Have the Going Home to Shiprock Blues, T.C. Cannon
Caddo/Kiowa
Oil on canvas
84" x 60"
Acquired: 1966
IAIA Permanent Collection: CD-10

AN ECLIPSE POEM FOR T.C.

I saw an old Indian,
Sitting out there,
In his power
of colors.

He released a color,
It floated to you,
You shared it.

You showed me
Each color
As you filled
My empty spaces.

Now my heart
Is enclosed, and
I don t know
Which color holds me.

That Black space - - -
That Red space - - -

I wait in my silence,
My center is lost,
My mind, my soul,
My heart turns, to you.

You smile with,
Bright reflections,
and say, All is
not lost.

Brother, when that
time comes, we will
Paint the sky,
With day colors - - -
With night colors - - -

That Red space - - -
That Black space - - -

Each man returns,
To find his source.

We will sing,
together,
Floating,
Like there is no tomorrow.

Ted D. Tomeo-Palmateer

In a sense Cannon's works are all self portraits of a generation of Indians who sought justification for Indian lives, asking for acceptance of Indian ways and wanting to keep alive those very ideals in themselves.

Cannon's works in the National Collection of Contemporary Indian Art range from totally abstract to semi-realistic. The strongest works are those in which he developed layers of image, color and meaning using reds, yellows and blacks to create movement. Figures became shapes, faces became blurred and words floated across the canvas like street lights reflecting off car windows. Each work became a journey to another place, another time. *It's Alright Ma, I'm Only Singing* is a portrait of Bob Dylan in a deep, moody pose, surrounded by stenciled words that ask "What's with Zimmerman," referring to Dylan's real name. Cannon was attracted to Dylan's ability to speak directly to the ills of the times through his music with wit, satire and beauty. Perhaps Dylan could have had as much influence on Cannon as anyone, including the instructors at IAIA. Dylan was addressing the issues of Cannon's generation. The exploitation, oppression and lunacy of government that Dylan sang about must have struck a chord with Cannon's views about the treatment of Indians.

Tommy Wayne Cannon was a musician influenced by the folk era. His work talks about that time, Indians in bars and discos, as well as waiting for buses.

Yet, despite his affinity for the protest music of his time, he enlisted in the army and was a Vietnam Veteran – 101st Airborne Division – where he served as a paratrooper during the Tet Offensive and received two Bronze Stars for heroism. His war experience influenced him as well. After the military, his work took on an angrier tone and scenes of war, warriors and the fighting spirit of his people became more predominant. Cannon's involvement with both Dylan and the Kiowa Black Leggings Society (a Warrior's Honor Group) of which he was a member, became a symbol for bridging both worlds, commenting on one another as they passed.

In 1966 Cannon wrote about his philosophy toward painting:

"Every painter should be apocalyptic. Each new painting should be a revelation or insight into another field of visual as well as emotional sensation. Each sensation should be analyzed as the viewer wishes and the artist, if thoughtful about his convictions and bound by debts to himself, should guide himself in that direction to which he is moved regardless of the favorable move prescribed by others. [Editor's note: At this point, Cannon crossed out a sentence he had previously written: "After all they don't paint the pictures..."] I will stick to this belief and follow it thru because I believe that an artist, regardless of the influence he obtains from others, can not afford to be influenced by that which is told to him by others who wish to form him or it will cause the destruction of his idiom, as a painter. Painting would no longer be personal, but a group discussion that not only speaks the painting but paints it." (4)

Of Cannon's work, Lloyd Kiva New, in writing a letter to the Hall of Fame for American Indians in support of Cannon's induction, wrote what turns out to be a capsule statement of the purpose of IAIA as seen in the personality of T.C. Cannon:

"T.C.'s contribution to the flow of American Indian cultural annals is impressive in that he broke through the barriers of confusion and unnecessary prevailing constraints that had become an impediment to progressive creativity in Indian art. He managed this through an unusually deep – and sometimes anguished – searching philosophic commitment and devotion to his own personal accomplishments – not only in the realm of painting, but in personally expressive music and poetry." (5)

A memorial service was held for T.C. Cannon at IAIA on May 18, 1982. At that time a life sized sculpture of a figure holding a feather fan, draped in a blanket, was donated by Doug Hyde, an IAIA classmate of Cannon. Students, artists and friends wrote poems dedicated to Cannon as a way to remember how one Indian artist can influence a generation of thinking. His friend, Grey Cohoe, who has also passed away, wrote the poem on the next page to the memory of T.C.

HE HAD A DREAM

for T.C. Cannon

Earth is formed, miraculously
in mirror of sun colors
as rainbows across earth formations
partaken by a dreamer
and redesigned by rain in the spirit

and reformed into visions in the skies
and re-sung in sacred thunders.
Wind of life had ripen on earth's face
in thirsty stones, olden trees,
thirsty rivers-flesh of earth
to create new eyes to enliven earth's
laughters in inspiring new images
all to re-rhythm the heart of earth.

All these visions before me,
I walk in astonishments
seeing myself in painted skies,
learning to sing secrets song of thunders,
reforming earth formations in my hands,
sharing the coming of dreamer's visions.

Grey Cohoe

Dan Namingha

Dan Namingha, the great-great grandson of the famed Pueblo potter Nampeyo, has become one of the most prolific graduates of IAIA and has continued to develop his creative expression as well as operating his own gallery in Santa Fe. His student works at IAIA were explorations in mood and color, grayish sky-like canvases with three dimensional forms and shapes in the upper right corner that appear to be passageways to other worlds.

However, Namingha recalled that those works were taken from him before they were completed. Known for the large colorful landscapes and scenes from his Hopi community, he breaks an object, a house, a landform into geometric forms and reconstructs it using color, creating a sense of space, light, movement and spirit.

Namingha began his art career in 1967 at the age of 17, studying art at the University of Kansas, followed by two years at IAIA.

By nature quiet, he found critical support at IAIA from fellow Hopi artist and instructor, Otellie Loloma. "She told me 'Just create,' create how you feel. Don't use photographs, but exercise your imagination." (6)

The artist feels that Loloma helped him to loosen his approach to art. His new approach is based upon inspiration from the land itself. The clouds and the shadows they create over a very colorful landscape.

In addition to the influential experiences of his tribes – Hopi and Tewa – he also acknowledges the influence of other artists such as Picasso, Matisse and especially Paul Klee. In 1979, Namingha created a 27- foot mural for the Sky Harbor Airport in Phoenix, entitled *View from Walpi*. A Phoenix reporter described Namingha's art in 1981:

"It is modern art, as much a part of this century as space shuttles and micro-electronics. It makes one want to reach out and touch, become part of, explore. It is wonderful, positive, exhilarating art that could have only been created here, now, in a Southwest tumbling into the future with unparalleled brilliance... It is ancient art...an art where the living spirits of the land have impregnated the pigments and worked their will through the brushes. Where an all-prevailing wind of mysticism blows across the soul..." (7)

In 1985 the National Aeronautics and Space Administration invited Namingha to witness the launching of the space shuttle Discovery and create a work of art based upon his reaction. He had left Hopi to watch the space shuttle liftoff after participating in a Kachina ceremony to call upon the rain spirits. He saw the parallel between the two as the Discovery shuttle headed for space. "Here I am...watching men go into space when I had just come from the place where these men were going." (8)

He created a painting entitled *Emergence*, which shows Hopi spirit figures – the Sun-Spirit, the Twin War God and a "Kokopelli" – floating in space with an astronaut in a space walk suit.

"What matters is color. I'm trying to capture the spirit of the land itself. There's so much to work with. You find so much in the land... There's a lot of texture and Cubist forms in there and a lot of play of light and shadow. "(9)

RIGHT
Autumn Morning, Dan Namingha
Hopi
Acrylic on canvas
120" x 80"
Acquired: 1983
IAIA Permanent Collection: H-8

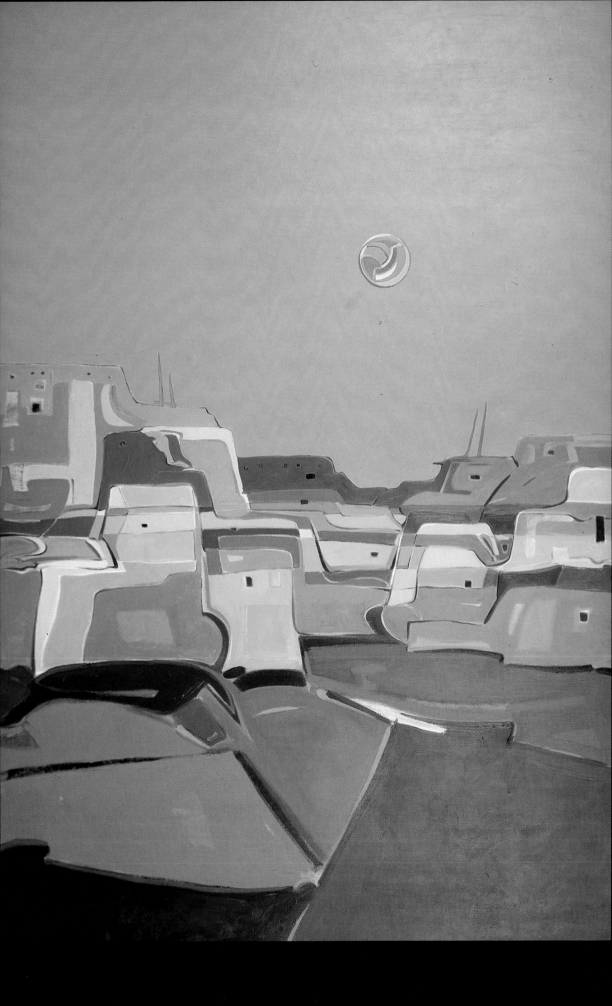

Bill Soza

This work by Bill Soza, a Cahuilla/ Apache Indian born in 1949 in Califor- nia, resulted from a combination of personal vision and the emerging na- tionalism that swept Indian Country during the late 1960s. Soza attended the IAIA high school from 1964 to 1968 and produced this work during his graduate studies at IAIA in 1969. The painting is an important work in con- temporary Indian art.

Conceptually, the three-piece work is a review of the impact of the Ghost Dance on establishing a sense of unity and destiny among the Plains Indians. It is also a view of what the dance repre- sents spiritually. Above the scene of the encampment we see the stars as they circle the moon as if to create a path for our journey into the spirit world. The Ghost Dance advocated a belief that if Indians returned to the sacred rituals, they would have visions in which they would be reunited with their dead relatives. The earth would rise up into the sky. Upon it's return the buffalo would be plentiful and the American soldiers would disappear.

Soza became a modern day "war- rior" in his own right and participated in much of the Indian activism of the 1970s including the takeover of the replica of the Mayflower at Plymouth

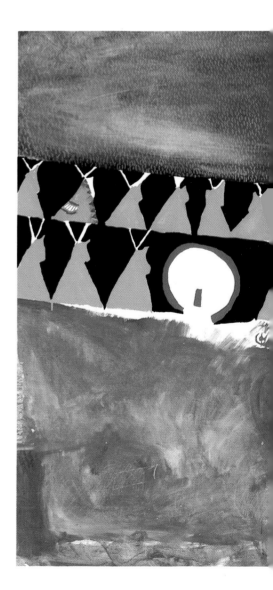

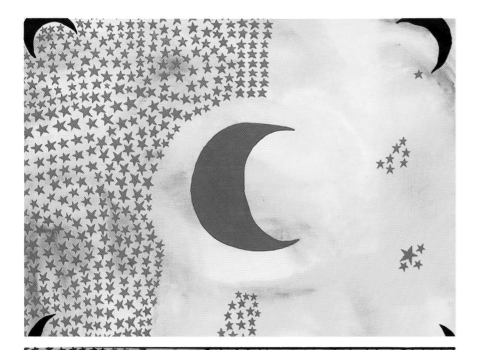

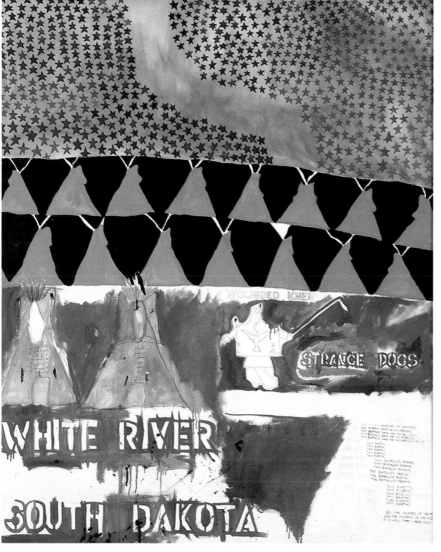

Rock on Thanksgiving Day, 1970; the reclaiming of Alcatraz Island in San Francisco Bay in 1970 and the takeover of the Bureau of Indian Affairs Building, Department of the Interior, in Washington, DC in 1971. His personal commitment to social activism and the pursuit of Indian rights led him to several brushes with the law.

Eventually he became a fugitive from federal charges, was later convicted and sentenced to serve time in the penitentiary.

"I had various exhibits of my work from 1966 to 1973, but I was a federal fugitive at the time, so I couldn't attend. During the past decade my radical political beliefs have not changed, but have been strengthened through outside experiences in the Indian underground. Demonstrations, takeovers, occupations only lead to bloody confrontations, arrests, beatings, murders; to be beyond this law you must be wanted… Through my art I say what is inside of me and direct it at the U.S. Government and fear no reprisal because it is my art." (10)

Ghost Dance, Bill Soza
Cahuilla/Apache (Mission)
Oil on canvas
Triptych Part I: 50" x 40" Part 2: 60" x 50"
Part 3: 50" x 40"
Acquired: 1969
IAIA Permanent Collection: MS-8,9,10

David Bradley

David Bradley has the distinction of being the first Indian artist to win awards for Best of Painting and Best of Sculpture at Indian Market in Santa Fe, New Mexico. From the White Earth Reservation in Minnesota, Bradley was deeply affected by his work in the Peace Corps in Central America. There he was befriended by a Mayan family and gained a new sense of vision. He has returned to IAIA as an artist-in-residence and has led a movement to remove the fake Indian art from the marketplace and to help Indians gain access to mainstream institutions.

"I am returning water to the well by sharing my eleven years of experience on the battlefield of professional art with young Indian artists... When I first entered the somewhat glamorous world of professional art, I thought I would steer clear of politics and keep my life as simple and positive as possible. Eventually, I realized that Indians are, by definition, political beings...

I saw the continual exploitation of the Indian artist community by museums in the Southwest... I witnessed multi-million dollar fraud by pseudo-Indian artists... I felt that it was my responsibility to do the right thing and so began to speak out on what I saw as widespread corruption in the art world... The idea of Indians and Indian artists selling out to non-Indian commercial or political interests at the expense of the Indian community must be discussed openly for the sake of finding solutions..." (11)

ABOVE
Indian Affected By Anti-Indian Backlash, David Bradley
Chippewa
Alabaster
9-1/2" x 9" x 7-1/2"
Acquired: 1979
Yeffe Kimbell Memorial Purchase
IAIA Permanent Collection: CHP-77

Art Haungooah ==

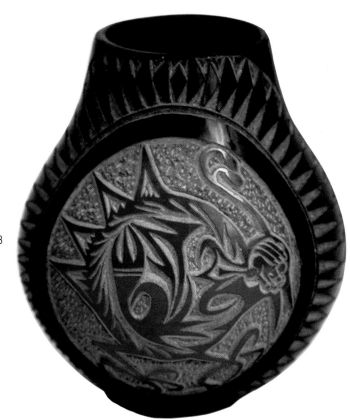

RIGHT
Untitled, Art Haungooah
Kiowa
Incised clay
3" x 2-3/4" x 1"
Acquired: 1977
IAIA Permanent Collection: KI-28

Art Haungooah came to New Mexico from Oklahoma in 1970 hoping to get a job at Los Alamos. He was returning to the Pueblo community of Santa Clara with his wife Martha Suazo. He soon began to carve delicate decorations into the miniature pots his wife made. By the time he came to IAIA, his work was already selling very well, yet Haungooah wanted to learn more about the arts.

The designs he carves are a unique combination of historic motifs from many different tribes combined with his own sense of design. His designs have received criticism from those in the Southwest who believe ceramics should not change in design. Haungooah has stated that he has been shunned by "traditional" potters who have adopted the narrow view that Indian art belongs only to the past.

Kevin Red Star

The work of Kevin Red Star exemplifies the results of the first decade at IAIA. A Crow Indian born in Montana in 1942, he studied at IAIA from 1962 to 1964. From there he attended the San Francisco Art Institute and later, Montana State University. His first one-person exhibition was in 1971 at the Museum of the Plains Indian in Browning, Montana. His early work drew heavily upon his Plains Indian culture using Crow art and design concepts to inspire his own interpretations of the life force that exists beyond the surface of decorated objects.

"Indian culture has in the past been ignored to a great extent," Red Star stated in the brochure to a 1971 exhibition, "It is for me, as well as for many other Indian artists, a rich source for artistic expression… An intertwining of my Indian culture with contemporary art expression has given me an enlightenment and greater insight concerning my art. I hope to accomplish something for the American Indian and at the same time achieve personal satisfaction in a creative statement through my art." (12)

At IAIA Red Star found that other Indian artists held a common bond, even though they were from different tribes. The circle of friends he developed there continued to help each other after IAIA. "At first I was homesick but when I met people like Doug Hyde, the late T.C. Cannon and others from around the country, I found that they had the same feelings," stated Red Star in a 1990 interview. "They wanted something but they didn't know what. We had the best instructors, the majority of which were Native American. It was exciting and I quickly found that I didn't have time to be homesick." (13)

ABOVE
Great Bearskin
Kevin Red Star
Crow
IAIA Museum Permanent Collection: CR-35

He felt that the friendship he experienced at IAIA helped him keep in tune with the art scene and also created a positive sense to keep creating. Lloyd Kiva New described Red Star in his support letter to the San Francisco Art Institute as being in the "happy position of being able to tap his cultural heritage for many of his inspirations, coupled with ambition, industry and a quiet, gentle dignity... I predict that he will be one of the outstanding painters in this country." (14)

Red Star returned to his own community to teach art and served as Crow Tribal Art Consultant, helping to form the Crow-Cheyenne Fine Arts Alliance to organize art exhibitions.

He became the first graduate of IAIA to return as artist-in-residence in 1976. He was selected as Artist of the Year by *The Santa Fean* magazine in 1976-77. At that time his work was mostly portraits of Crow people, with exaggerated features, colorful clothing and dark layers of background colors. The reflective mood of his paintings attracted attention. The visual effects of texturing, something he learned in his student work at IAIA, is evidenced in the work included in this exhibition. They have become a distinguishing feature of his art. The Red Star works in the National Collection of Contemporary Indian Art are large canvases on which he experimented with textures, overlapping objects, collage and dark colors that took historic Indian objects and reworked them as if to show the spiritual power behind the object.

Larry DesJarlais

Larry DesJarlais was born in 1945 on the Turtle Mountain Indian Reservation in North Dakota. He came to IAIA to study commercial art. Last year DesJarlais designed the campaign logo for the National Museum of the American Indian, part of the Smithsonian Institution. "The two years I studied at IAIA gave me more than an education in the arts – it helped me find myself and for the first time in my life at the age of 21, I was proud to be an Indian." (15)

Of his own work, DesJarlais states "I am expressing that we were once a great and powerful people. Our ancestors are gone and forgotten by many. Through my artistic efforts they can live again and roam their country as a 'Free Spirit.' ... I would say that contemporary Indian art...is art performed by persons with Native American descent using free expression in his/her cultural beliefs." (16)

LEFT
Peace Chief, Larry DesJarlais
Chippewa
Fired Stoneware
22" x 10" x 6"
Acquired: 1989
IAIA Permanent Collection: CHP-148

Laura Fragua

"An effective piece of contemporary art is evaluated on its own artistic merits, not by widely accepted boundaries of Native American art categories. Accepting those standards can, for me, be difficult. That is one of the main reasons I'm attracted to contemporary forms of art work."

Laura Fragua (17)

ABOVE
Just Because You Put Feathers In Your Hair Don't Make You An Indian, Laura Fragua
Jemez Pueblo
Painted clay, multi-media
19" x 16"
Acquired: 1991
IAIA Permanent Collection: J-72

Peter Jones

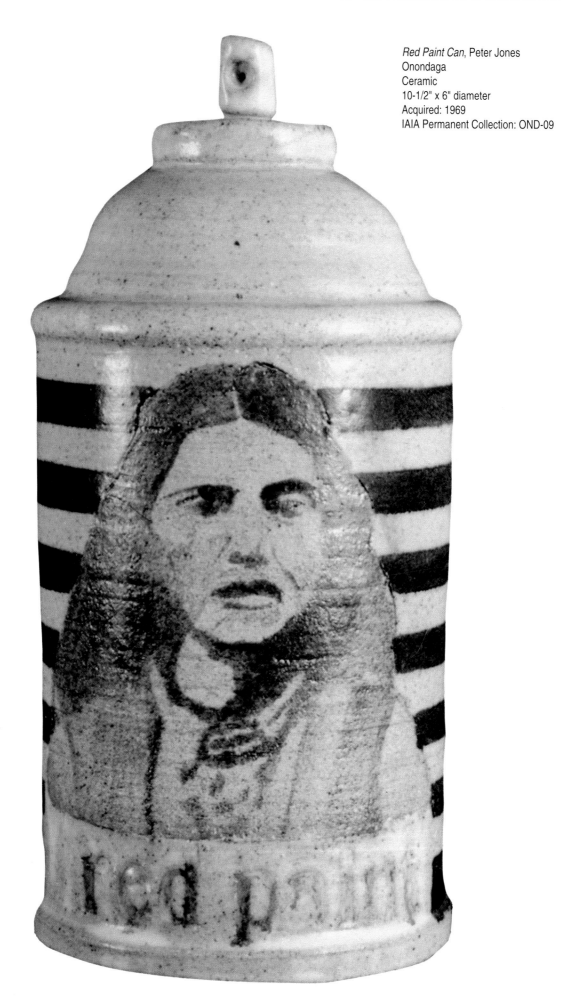

Red Paint Can, Peter Jones
Onondaga
Ceramic
10-1/2" x 6" diameter
Acquired: 1969
IAIA Permanent Collection: OND-09

Peter Jones, an Onondaga Indian who grew up on the Seneca reservation in western New York, came to IAIA at the age of fourteen in 1963. He credits Otellie Loloma as the most important influence on his creativity. He explored the use of clay to express his feelings of being an Iroquois Indian. Jones has led the way for Iroquois artists in the revival of the use of clay, developing two distinctive forms of expression. He has produced both ceramic vessels modeled after ancient Iroquoian pottery and figurative works that are commentary on Indian social issues of today.

Jones created works that are technically challenging and use clay in ways that had not been seen before in Indian art. In his 1965 work, entitled *Red Paint Can,* Jones brings us an early view of the Indian rights movement and the re-emergence of the Indian warrior as artist. The stoneware spray paint can has an image of a contemporary Indian as if the very contents of the can are "Indian."

At IAIA Jones developed a technique of hand-built ceramic figures made from very thin clay slabs. The work illustrated here is an example of his very early explorations into new approaches of ancient artforms. Of his own work he states:

"I believe that all the time I spend in a creative endeavor is time well spent - an end in itself and not a means to something else. I choose clay because it is an immediate medium that lends itself to spontaneity of creation. It is the spontaneous property of clay that enables me to express myself... I wish to experiment and discover the possibilities and limitations of the ceramic medium." (18)

Coyote With Fan, Diego Romero
Cochiti Pueblo
Clay, paint, leather, feathers
8" x 4-3/4" x 4-1/4"
Acquired: 1986
Gift of the Artist
IAIA Permanent Collection: CO-32

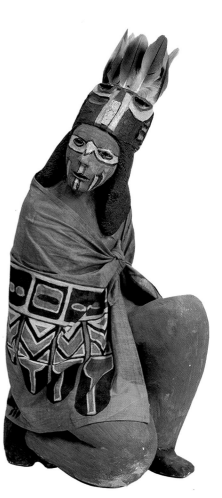

Sit and Wait, Dave Tussinger
Spokane
Clay, cloth, feathers
25" x 10" x 10-1/2"
Acquired: 1971
IAIA Permanent Collection: SPK-032

Coyote With Pot, Diego Romero
Cochiti Pueblo
Clay, paint
7-1/8" x 5-3/8" x 5"
Acquired: 1985
IAIA Permanent Collection: CO-31

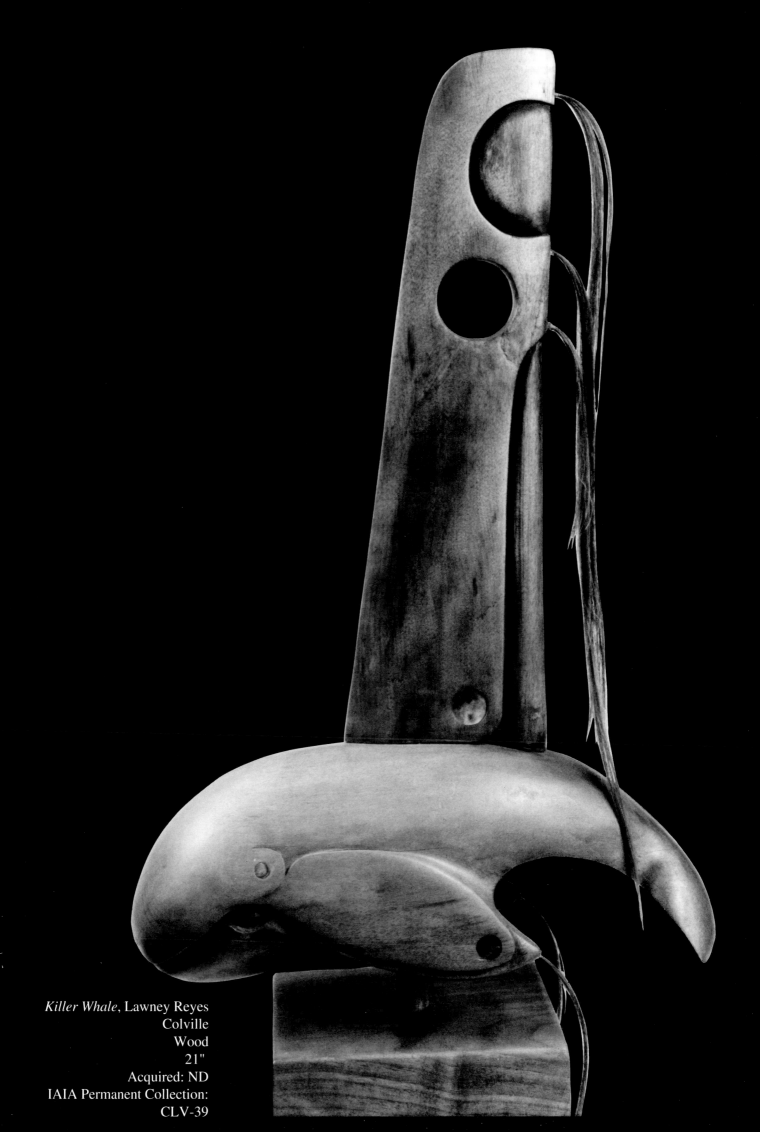

Killer Whale, Lawney Reyes
Colville
Wood
21"
Acquired: ND
IAIA Permanent Collection:
CLV-39

Corn Maiden, Preston Duweynie
Hopi
Clay
16-1/2" x 5" diameter
Acquired: 1982
IAIA Permanent Collection: H-142

Bird Spirit, Shirley Bauker
Ottawa
Ceramic
12" x 6"
Acquired: 1990
IAIA Permanent Collection: OT-10

First Love, Jerilyn Lujan
Taos Pueblo
Clay
11" x 10-1/2" x 10"
Acquired: 1988
IAIA Permanent Collection: TA-144

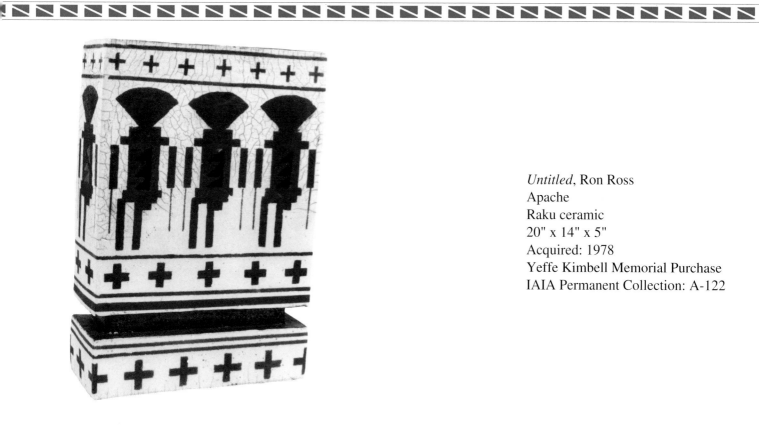

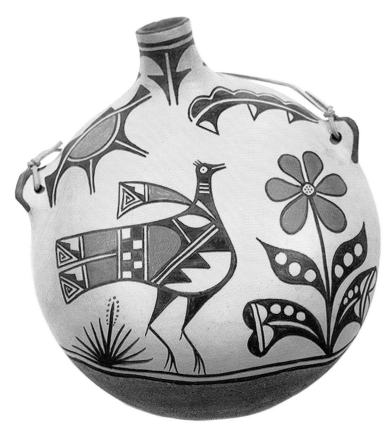

Untitled, Ron Ross
Apache
Raku ceramic
20" x 14" x 5"
Acquired: 1978
Yeffe Kimbell Memorial Purchase
IAIA Permanent Collection: A-122

Ceramic Canteen, Robert Tenorio
Santo Domingo Pueblo
Clay
12-1/8" x 10-3/4" x 5"
Acquired: 1974
IAIA Permanent Collection: SD-91

Touch The Earth, Raymond Hamilton
Miwok
Oil on canvas
68" x 68"
Acquired: 1974
Gift of Artist
IAIA Permanent Collection: MIW-36

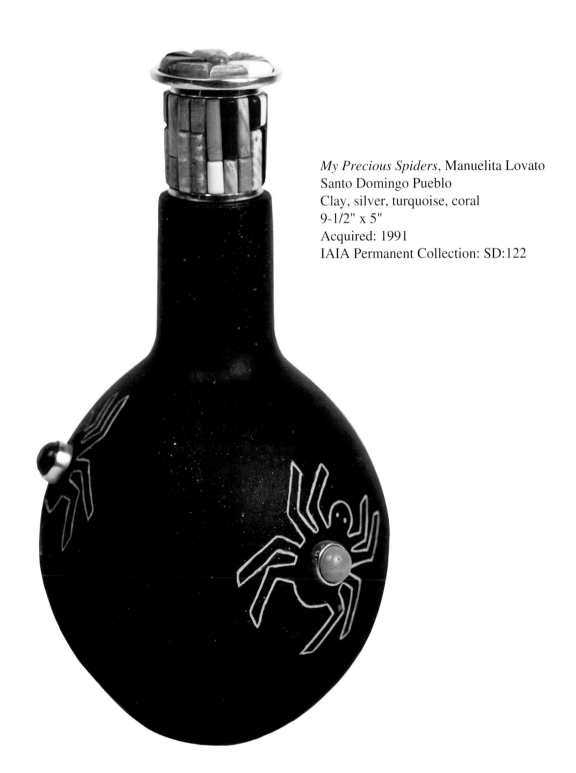

My Precious Spiders, Manuelita Lovato
Santo Domingo Pueblo
Clay, silver, turquoise, coral
9-1/2" x 5"
Acquired: 1991
IAIA Permanent Collection: SD:122

Voice, John Kailukaik
Eskimo
Acrylic on canvas
59-3/4" x 84-1/4"
Acquired: 1971
IAIA Permanent Collection: ESK-066

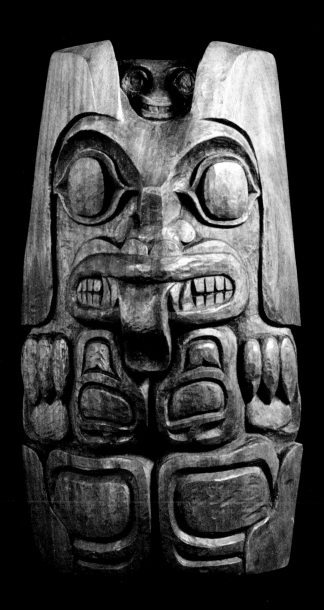 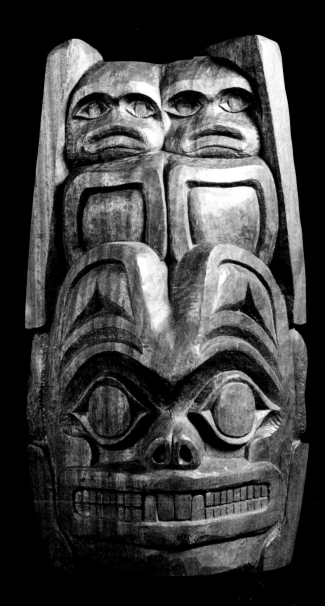

ABOVE
Totem, Bill Prokopiof
Aleut
Mahogany
24" x 12-1/2" x 10"
Acquired: 1967
IAIA Permanent Collection: AT-4

Bennie Buffalo enjoys a study break, under his painting Red and Blue Blanket on a Pendelton.

CHAPTER FIVE
A GIFT OF TIME

One alumnus of IAIA recalled his experience here as "a gift of time." This best expresses the function of IAIA. It was time to experiment and explore new ways of expressing ancient values, traditional perspectives and modern realities. Students at IAIA meet other Indians from around the country and are given the opportunity to exchange ideas and beliefs.

Inter-tribal exchange is actually a very old pattern of sharing that Indians had known for centuries. Since prehistoric times, objects, raw materials and ideas were exchanged through a system of trade routes.

In one sense IAIA continues the ancient tradition of sharing and exchange. Students are influenced by increased knowledge of their own tribal heritage as well as other tribes. The Indian faculty encourages students to take the time to learn, understand and to develop their personal vision of Indian reality.

Over the thirty-year history of IAIA, the Institute has not advocated a particular style or world view. Instead, students learn about a variety of artistic styles and methods. New materials and approaches are encouraged. The legacy of IAIA is the gift of time to meet, exchange, learn and create.

Harold Littlebird, of Santo Domingo Pueblo and a 1969 graduate of IAIA, describes the inter-tribal cultural exchange and the freedom he felt at IAIA:

"I meet people from other tribes here and I see what they're like. It's good. You have to be aware of everything around you. You can't just stay within one thing. Most of the faculty people here are real cool. And that's good. The students feel more with them. There is a strong contact among the faculty, too. They don't tell you what to do or just how to do it. They give you the basics but they don't tell you to go this way or that way. If you want to stay traditional, you can – if you want to go contemporary, you can. If you want to do your own thing, it's fine. You can do it." (2)

In the first twenty years, IAIA received a great deal of worldwide recognition. Students from IAIA consistently won national awards and prizes in art competitions. Exhibitions produced by the IAIA Museum travelled around the world. Nationally recognized Indian artists were attracted to IAIA as instructors. Such artists as Allan Houser, Charles Loloma, Fritz Scholder, Otellie Loloma, Neil Parsons, Josephine Wapp, and Louis Ballard were among the artists who changed a generation through the arts.

MURALS EMERGE ON THE IAIA CAMPUS

Alex Jacobs, Mohawk, designed a mural of an Earth Turtle and an Indian figure in 1976-77 which he stated was:

IAIA ALMA MATER
Oh, the cottonwood trees are swaying
All around us here today
And all our thoughts are straying
To our home in Santa Fe.
I-A-I-A, we sing to you,
The school where dreams come true.
Within these halls our hearts will stay,
Though we are far, far away

"... a synthesis of the Iroquois from which I came and where I pull many symbols and their varied meanings. It is finished, though, through my own aesthetic and expression of form ... The symbols of our people are rich in meaning and powerful in imagery, depending upon you, the artist, when combined with you/our personal ex-pression and any tribal perspective, these symbols can and should change. They can become more open and clear, more mysterious and deep, depending upon your culture, language, folk-ways, tribal ways, personal vision or feelings that time, space, borders and dictates cannot erase, unless, of course, we let it happen ... " (3)

Jacobs is of the Turtle Clan so the image held personal meaning for him. The man figure was designed to recall the ancient Indian clay figures. Together they share the rhythm of IAIA Santa Fe, New Mexico and the American South-west. This mural was executed by Tom Coffin, Potowatomi, an IAIA graduate. Alex Jacobs produced an Artist's State-ment that reflects the attitude of many of the students of that era:

"Santa Fe was this mythical, mysti-cal place ... and Indian Art was this mythical, mystical entity that was ev-erywhere in the air but hard to get a hold of. I had attempted Indian Art and was not satisfied, I didn't know if it was Indian Art. I didn't know if I was an Indian Artist or even an Indian, but now I would be exposed to and be taught Indian Art.

Reality soon took over ... Santa Fe was unique and pleasant but also crass and commercial.

The tri-cultures, Hispanic, Indian, and Anglo made feeble attempts at understanding each other. Old-timers were adept at getting along but it was the young people who both exposed the biased teachings of their parents and also made sincere efforts at understanding. The expectations of students met the limitations of studios

Tom Coffin painting a mural at IAIA in 1976.

end, we were just students experimenting with materials, and we were brothers and sisters who were building or creating or defining something called "Contemporary Indian Art" together. Now, this art could be traditional or modern; it could be very physical or very ephemeral or conceptual; it could be precious materials or found objects. But it was made by "us" who were the outcome of tradition-history-reservation life. We were not our grandfathers and grandmothers, but we represented them and their dreams and their resistance and their Indian ways. We attempted a modern-day "break-out" out of the "reservation" called "Indian identity or Indian art."

Just as the local culture of the Pueblos created a home feeling, knowing that tradition was being continued just down the road, us "national" Indians also tried to make it feel like home. There were drums and songs and pow-wows and 49's and stories … even as we tried to understand the Indianness of other skins, and how other people of the world treated art, and how our people related to what would be called art; we would debate, argue, fight, cry, laugh, support each other. These emotions, along with feelings for home, teachings of history, relating to our past, would of course "break-out" before our art was made reality.

and the bureaucracy of a "government" institution.

The feeling of "Did I do the right thing?" did not last long. From the beginning, the mix of Indians from all over Indian Country, students, teachers, artists, characters, rez and urban "skins," was an exciting-interesting-confusing-overwhelming motivating factor. Students learned as many different techniques as possible within an art form. Many were able to learn other art forms outside their chosen medium. We could work all day, all night, all weekend. Someone always had access to a studio and appreciated the chance to work.

I found out that many Indians felt as I did, that we knew what "Indian" was, but how do you make it into art. In the

The English language with reservation dialect and meanings, was one of our common grounds, the way we did not write the histories but had to learn it and somehow appreciate it, the way we were always "told to do" whatever it was we were to do as students or Indians or government property, the way we put that all aside and got together, all the reservation English between the songs and drums … we were creating poetry and this poetry, emotions, feelings. Dreams would spill out and sometimes we did not know if it came from us or our parents or our elders or even our future children.

Sometimes that poetry was brutal, often beautiful. It could be physical or surreal, but it was never dull. And for everyone who cried about not knowing, there were more who shouted they did know and that, from this point on or from some other point defined in Indian history, we were "breaking-out" come along and join us or be that way then.

In 1975, upon my arrival, there was no school paper or magazine, but Creative Writing had a small press type student anthology. Soon, the students got together and with support from both the college and the high school, we started *The Student Publications Workshop*. Although we had advisors and the material support of both schools, it was emphatic that the students were in charge. They named the paper *Newborn*, (the previous paper was called *Drumbeats*), and Arthur Redwing

and myself (editors) just let them go at it for the most part, both high school and college students, for credit, for experience, and for sheer will power. The energy was great. The process was open to all. The format of the paper allowed plenty of room for all expressions. The writing was uneven, but it was across the board and we knew in time it would only get better. The Creative Writing Department eventually created many new projects and titles. The one that stuck and got the most attention was *Spawning the Medicine River*.

In retrospect, I feel it was the wide open feeling of the project, the emphasis on student control and context, yet open to what all advisors and teachers had to offer, that motivated students. The response from home and elsewhere was good. Most students with a little effort could be found in the paper, but Creative Writing (and Graphic Illustration) still were the primary focus. This allowed any "literary bias" or any suspicions against "poetry" to dissolve and actually encouraged people to write Indian poetry.

The "Indianness" of the Institute had many different contexts, but on a student level, the way we hung together and created our own "reservation (territorial) identity" while faced with the government context of a reservation (boarding school), was a motivator. The "Indianness" of *Newborn* was that it was inclusive of all students and departments, as compared to or opposed by an exclusive "small writing

in small books" typical literary formats. Although that is still the standard for poetry and creative writing, the definition of an Indian context created the desire to participate, to learn and to grow.

Alex Jacobs, 1977 (4)

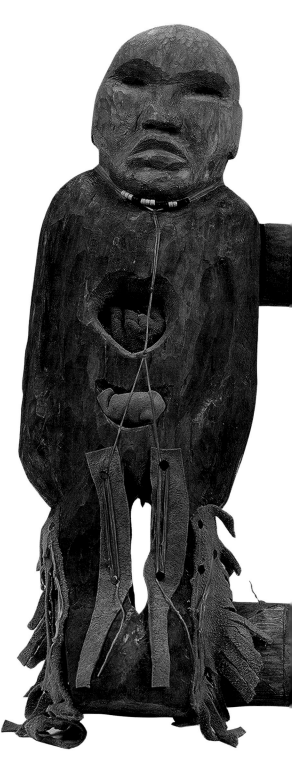

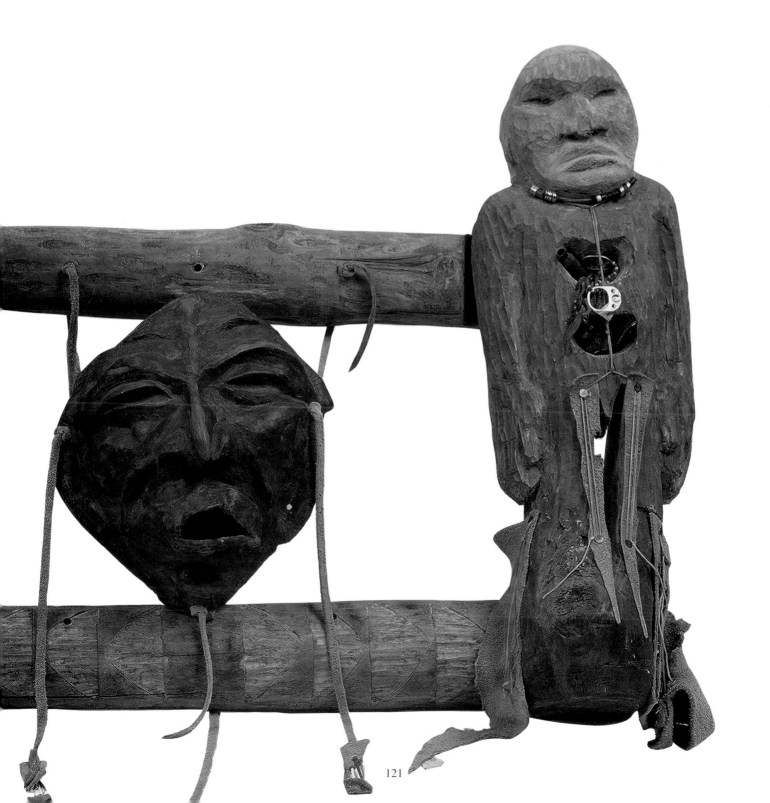

Poems

Poetry Emerges as a New Form to Express Indian Thinking

Poetry became a more significant aspect of the arts at IAIA during it's second decade. The student publications became filled with poetry and short stories. Martha Conallis, a Sauk and Fox, junior college freshman at IAIA in 1977, called herself an "sionist poet." She won recognition for her work by receiving a recommendation from the Poetry Society of Oklahoma. Her work, *Indian Summer*, won first place in the Writer's Guild Contest in Oklahoma.

NATIVE CHILDREN

Outside our mother's womb
we are singing and dancing
our medicine songs
around the fire we dance
our midnight hair flowing
in the wind
colors of feathers we
carry in our hands
dancing for the stars
and the cosmic gods
we are the colors of earth
we are from the past
brought to the future
by the skin of our teeth
together we stand
hand in hand we'll climb
up to the star ...

January Winter-Star
Loren Gaseoma

INDIAN SUMMER

My visions grow ripe as later years
are passing. A spirit dance quiets the
drum. The moon at this time is full and
lights the night. The ground soon will
shake as the buffalo accompany us in
their spiritual dance. Coming from the
sweat lodge, I am pure with content.
As I offer my thanks to the four corners
of the earth, She accepts my herbs with
trust. With the morning star in my
eyes, I see the Coming of greater
days. Restless in my sleep, I walk
with the fire.

Martha Conallis

PEYOTE CEREMONY

Sun goes down to meet horizon.
The evening dusk call the young
Indian.
To become one with the Peyote Bird.
Peyote will give him strength to
become a man. As the bird passes
through his body. A vision is flashed
beyond his searching mind.
The young man may be distorted for
awhile. But he will journey to the
Mountain People who will help him
gather his thoughts for tomorrow.
As he unites with his Indian people,
they know that he is the man with the
knowledge Of the Peyote Bird.
A knowledge he has learned that no
one will remove from his newly born
heart. It tells him he is a wise Indian ...
In the land of the Peyote Bird.

Martha Conallis (9)

UNTITLED

The days of my life pass quickly.
I try to remember them well,
but in a world of new creation,
knowledge, and intelligence ...
I sometimes forget who I really am.

Hilda Tsethlikai

UNTITLED

We went looking for America
but it wasn't where we left it.

Diane Burns

UNTITLED

As I run my horse
through the wide, open land
I can see the trails
that my old people
walked upon.
I can see the tears
that they left.
I can see the blood
that they shed in battle.
I can see the fence
that divides us from
what used to be sacred.

Keith Norris

PAST DREAMS, FUTURE MEMORIES

I'm sitting here
waiting for the sun to rise.
In my hand there's a picture
of your smiling eyes.
I wonder will we
see each other again
and if its to be
what could we do then?
Would it be worth our time
to chase after ghosts
of two people
thumbing their way to the coast?
Or to talk of the places we've been
near and far while we sit in a booth
in an Indian bar.

 Parris Butler

UNTITLED

They say the old ways may be dying
My parents they can understand
I still love my parents
And still love the old ways
I want to keep in touch with the old
ways
Keep my place in the Iroquois
Confederacy
I learn from my people
And learn from the old ways
They say the old ways may be dying
My parents they can understand
I still love my parents
And still love the old ways

 Tom Huff, 1977

SKINS

Bang, women running, some
with little babies, small kids,
not knowing what's going on,
ran for their lives, as the
brave warriors stand back,
ready to kill or die for
their land and their people.

The fighting ends, old and
young ones who never reached
safety,
their bodies scatter,
left in a bed of scarlet blood,
this is all forgotten.

We cannot fight back no more,
for the whites develop words of
laws over our once upon a time
land, they got all these ideas,
but we Native American Indians,
also have minds and powers of our
own, which can bring us back our
loved.
Mother earth, as we stand one
proud nation, red man.

 Julie Yellowhair

MY GRANDMOTHER

The woman she stepped softly
but firmly planted her feet.
On the dark soil of the earth
She started climbing upwards.
Plants grew everywhere she walked
and the animals followed behind.
She spoke gently to the wind, and
listened with awe to the water.
The trees waved to her wherever she
went and the earth breathed deeply
under her feet.
She was one with the earth
and everything it bore.
As she stepped into the first rays
of light, her face brightened
and she continued upward into the sky.
The sun was hers.
She was golden to the sun.

 Tom Huff, 1977

UNTITLED

Tomorrow you will dance and pour
your soul out to the drum,
an Indian soul, a woman's soul,
your dancing soul. Though you are
many miles away from your people,
you will dance with them;
dance the dances of a tribe you know
well. When you feel the buckskin
dresses swaying to your rhythm,
you will sing a song for the deer that
gave you a dress.
Tomorrow you will dance and pour
your soul out to the drum,
an Indian soul, a woman's soul,
your dancing soul.

 Melanie Ellis

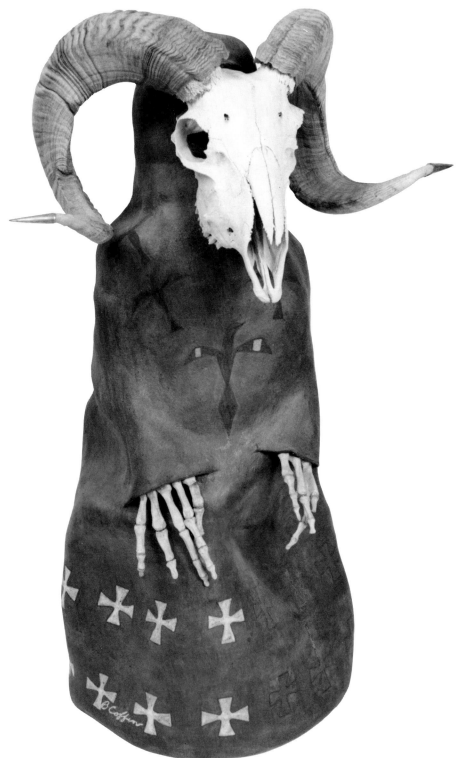

ABOVE
Ghost Dancer, Barry Coffin
Potowatomi
Multi-media
31" x 20-1/2" x 14"
Acquired: 1979
IAIA Permanent Collection: PW-9

ABOVE
Blue Head, Peter Jones
Onondaga
Ceramic
12-1/2" x 26-1/2"
Acquired: 1969
IAIA Permanent Collection: OND-55

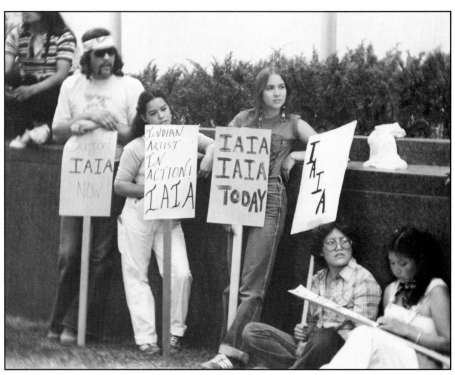

Students protest the removal of IAIA from the Cerrillos Road Campus in 1980.

CHAPTER SIX
MANY VOICES,
MANY REALITIES

For generations of Indians individuality has played a significant role in the arts. Artists gain status and respect through their skill, vision and ability to express individual identity within a visual literacy common to the community. Each person, artist or non-artist contributes a unique viewpoint to the circle of thought that eventually defines the group's identity. As Indian nations are comprised of such voices, each representing a different view of the realities of Indian life, every generation adds to this artistic legacy starting with a different artistic heritage, each defines its relationship to the land, the universe and the spirit world.

Josephine Wapp was the former IAIA Traditional Techniques and Fashion Design Instructor from 1962 to 1973. She believes the traditional techniques used by previous generations of Indians must be taught in order for the current generations to develop a viable form of expression in their own time.

"I believe the students should be led to appreciate the beauty and skilled craftsmanship that went into traditional clothing, housing, tools and weapons of their people. They should learn to respect those who were able to produce works of art with primitive tools and methods. Out of their appreciation should develop a desire to preserve this

heritage through adaptation of the use of materials and techniques to present day clothing and interior decor ... I believe there is therapeutic value for young people in transition between two cultures in learning the skills of traditional craft work and adapting these skills to modern conditions of living." (2)

During the high school era of IAIA, the traditional arts played an important role for young Indians in search of their cultural roots.

Beadwork, clothing, fashion accessories and weaving helped emerging artists to explore traditional techniques and learn more of the cultural concepts behind the work of their tribal nation and other Indians from the Americas. This was a very important aspect of the educational goals of IAIA. A Sioux student told a *New York Times* reporter that many of the students here had learned tribal dances, songs and customs. IAIA graduates who specialized in traditional techniques and have gone on to establish themselves in the Indian art world include Phyllis Fife, Imogene Goodshot Arquero, Bruce Miller, Wendy Ponca, Marcus Amerman and Manfred Susunktewa.

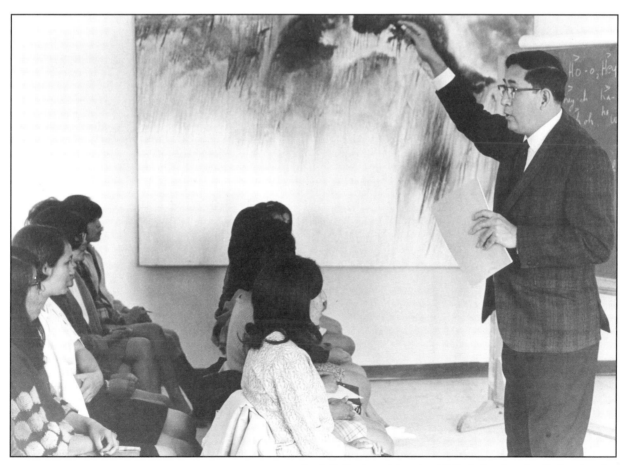

Louis Ballard taught music at IAIA during the school's first decade.

129

Beadwork at IAIA

Beadwork has become a "traditional" art form although Indians have been using glass beads for only five hundred years. Along with steel needles, glass beads, spun thread and European fabrics, beads were introduced to Indians through the early explorers and the fur trade. Yet Indians have fully adopted beads as a living form of expression.

Beadwork also under went changes at IAIA, as students found new ways to use beads, best demonstrated by the work of Marcus Amerman.

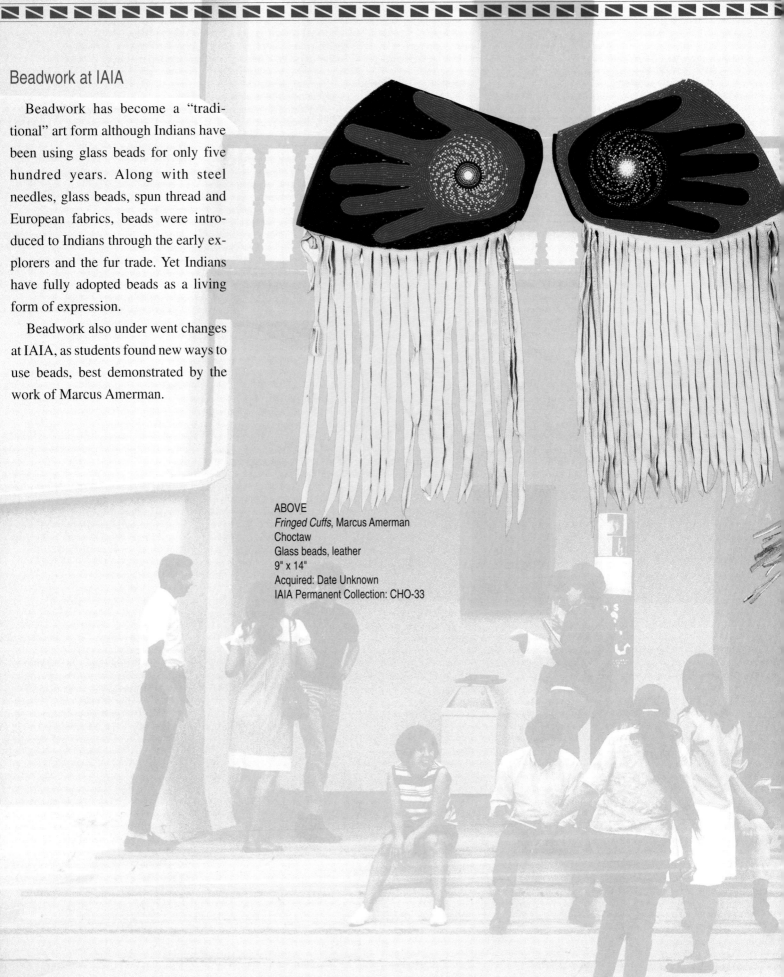

ABOVE
Fringed Cuffs, Marcus Amerman
Choctaw
Glass beads, leather
9" x 14"
Acquired: Date Unknown
IAIA Permanent Collection: CHO-33

130

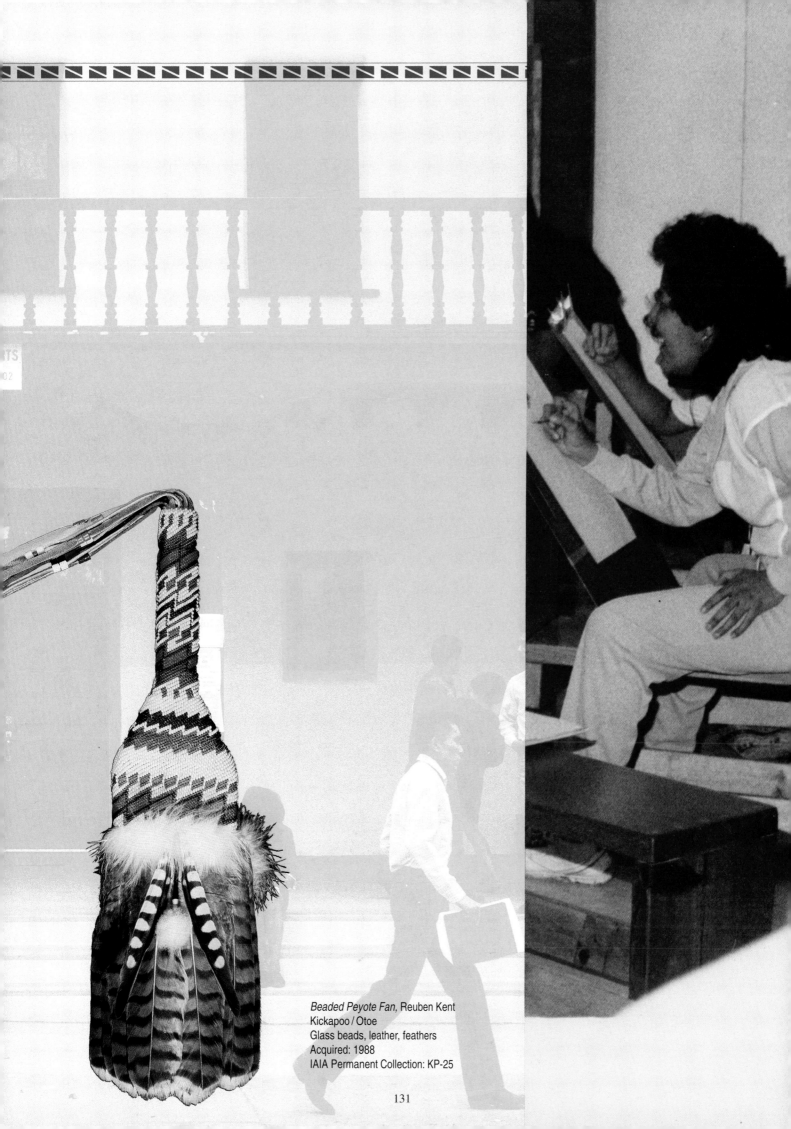

Beaded Peyote Fan, Reuben Kent
Kickapoo / Otoe
Glass beads, leather, feathers
Acquired: 1988
IAIA Permanent Collection: KP-25

131

Jewelry at IAIA

Jewelry underwent similar transformations at IAIA due mainly to the influence of Charles Loloma, the Hopi jeweler instructing at IAIA. Loloma challenged his students to create jewelry that reflected themselves and the world around them. Students recalled, "he taught philosophy as often as jewelry making." His students were encouraged to relate their ideal culture to their creative work. They could draw both inspiration and materials from the environment around the IAIA campus.

Loloma had his students walk outdoors and find various stones, wood and other materials to be incorporated into their jewelry. He re-introduced the concept of using a variety of natural materials in jewelry making. Many of the works, especially the bracelets, reflect this approach. The style for which Loloma became famous, was developed at the IAIA jewelry studios.

He also introduced the use of insect forms in jewelry. Many of these early works were object lessons in both artistic technique and cultural attitude. Students heard stories about insects and then were asked to create a piece of art that reflected their own feelings.

Many of the insect pins in this exhibition were among the first of their kind to be made by Indians. Another way that IAIA has influenced the larger art scene.

During the first decade of IAIA most of the really creative works were taken from the students for the Museum collection. However, record keeping was not always maintained. The names of the artists who created much of the jewelry were not recorded. These works are included because they are exceptional and properly reflect the atmosphere of creativity at IAIA. Unnamed, but an important legacy of IAIA.

ABOVE
Bracelet, Norman Albert
Navajo
Silver, turquoise, coral
2'-1/4" x 2-1/4"
Acquired: 1986
IAIA Permanent Collection

RIGHT
Necklace, Anthony Lovato
Santo Domingo
Sandcast silver, with jet, coral
2-1/2" x 7"
Acquired : 1976
IAIA Permanent Collection: SD-76

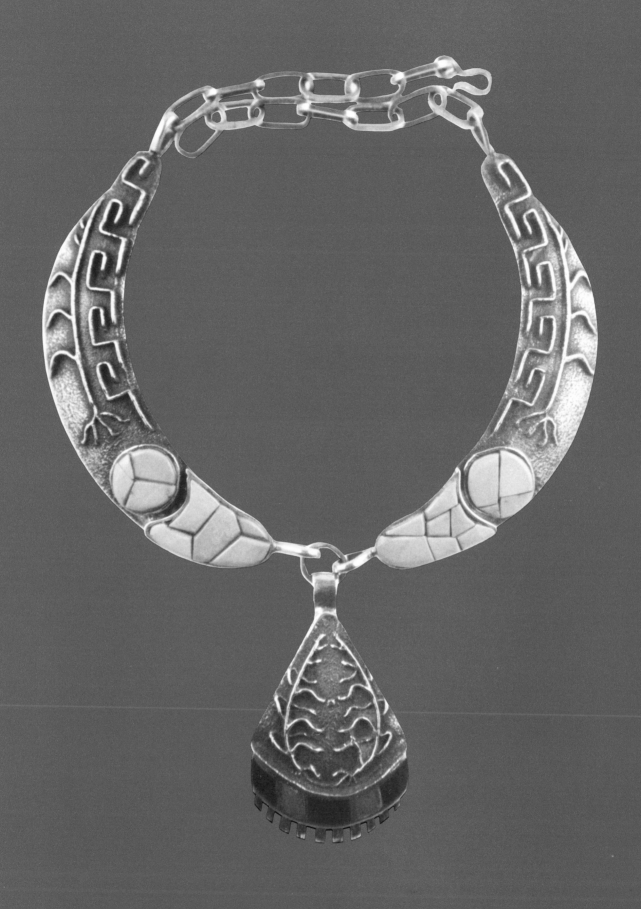

The Future of IAIA

Perhaps it is too early to judge the impact that IAIA has had on the Indian art world. Some contend that the influence of IAIA has already been over-rated. Others feel Indian artists need to study art beyond the cultural umbrella of IAIA, and should attend mainstream art schools for a true art perspective. Occasional art instructors teach that Indians should not depend upon Indian symbolism of the past. There is no consensus among Indians as to the best way to learn how to make art. Given this, we may ask: what will the next decade of Indian art be like? Will IAIA have a part of the larger Indian cultural scene of the future or has it's time come and gone?

Indian artists, spiritual leaders, educators and elders have gathered at a "vision session" at IAIA to bring direction to the Institute's future. These sessions are part of a comprehensive self-examination that IAIA is undergoing to redefine its mission and its approach to teaching art to Indians. With one hundred and forty acres of land on the outskirts of Santa Fe as the home of a future campus, IAIA can now begin to envision the next decade of institutional building. IAIA has to grow and change. Indian art has changed. Indian architects, Indian engineers, Indian artists and Indian elders will help to make IAIA a learning laboratory where new ideas can mix with ancient symbols; new voices can pick up where the last generation left off; where Indian artists, Indian intellectuals and Indian cultural thinkers can gather with their non-Indian counterparts to share the gift of time with each new class of Indian students. If the plan that IAIA has for itself comes true, it will be as if Indian Country has made it's first art treaty, to find the way that many diverse Indian cultures can unite in a common effort of mutual defense through the arts.

The future requires that IAIA begin to put forth a new dialogue about art from an Indian perspective. We must develop new forms of education that are culturally inspired, artistically challenging and personally rewarding for students and faculty alike. It will be a new partnership that will lead Indian art to it's next plateau. We could lead the way to new approaches, not the only approach, not the best approach, but a new way of looking at the significance of concepts of culture, spirit and creative vision. It all depends on the thinking and commitments of the next generation of students, it is they who must manifest what it is to be an Indian and use materials such as clay, stone, paper, paint, steel, plastics, electronics or whatever, embody their own visions.

If the premise of this exhibit is true – that creativity is the underlying tradition that produces a different form of

Above, Rancho Viejo, site of the future IAIA campus.

art, yet speaks to deepseated ideas – then the next decade will see art by Indians that is not like anything ever seen before. Yet, the work will seem strangely familiar to those aware of their Indian identity. No matter what form, style or technique employed in the next decade, Indian art will always remain Indian if it is true to the Indian values, beliefs and visions of the artist. If Indian art of the future needs any measure of critical judgement it only needs be true to the life of that creator/ artist/Indian. To have validity Indian culture must find ways to manifest itself in the everyday life of Indians, not just in several rituals during the year. Art is not just a museum function. Art is not the measure of resisting change; it is evidence of absorbing change into the constantly evolving world view ... to still remain a distinct people.

Art for Indians is a vital link to keeping culture a part of everyday thinking. The act of creating is, in a sense, a form of ritual by which Indians renew beliefs, solidify perspectives and give abstract ideas real form. It is an act of renewal and sharing which in itself is very Indian. This differs from art by non-Indians in that it speaks about the Indian world from within. It is a view that is only held by Indians. No matter how much you read about Indians or observe them, you cannot appropriate the feelings of being an Indian. Indians are not spectators in their life. No matter what the lifestyle, it is not up to anyone to judge the validity of that Indian life. How could they possibly

live some pure form of existence, untainted from 500 years of contact with European, African and Asian cultures? We must accept that not all Indians live alike nor hold the same beliefs. Indian culture was not meant to be a form of moral judgment against those who think or act differently. Intolerance is an adoptive behavior that creates an ethnocentric view. Art was not meant to be a form of missionizing an Indian belief. Rather, it is a celebration of that belief for the individual.

Indians have something of value to offer the world. Art may be the forum in which cultural knowledge can be truly shared, that we can experience the world as Indians see it, without violating any tribal/tourism taboos. The essence of beliefs can be expressed in such a way that those, from other tribal cultures, from other ethnic backgrounds, from other belief systems can feel the emotional power. Divergent viewers can share the ironic contradiction of being an Indian in America, culturally exiled in their own homeland. We can see how the Indian mind of the twentieth century functions, how it carries ancient ideas forward, creating new forms of thinking to advance those values and ethics. Through Indian art we learn how modern Indians feel about their history and see a side of history not found in textbooks, films or museums. Through Indian art we can see that Indians are still functioning on the world stage with a quality of thinking that can impact world cultures. Through Indian eyes we can learn to see Indians for what

they really are – diverse groups of people who honor creativity as a way to express themselves.

The legacy of Indian art is found in the responsibility to keep art a vital form of expression, beyond the museum, beyond the marketplace, beyond the stereotypes. Not all Indian artists achieve success on those terms, but in each generation there will be some with the power to explain what remains important to Indians across the generations. As viewers our responsibility is to look, hear, contemplate and learn.

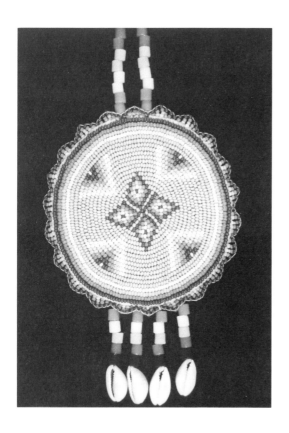

LEFT
Medallion, Celeste Connors
Apache
Glass beads
5" diameter
Acquired: Date Unknown
IAIA Permanent Collection: A-42

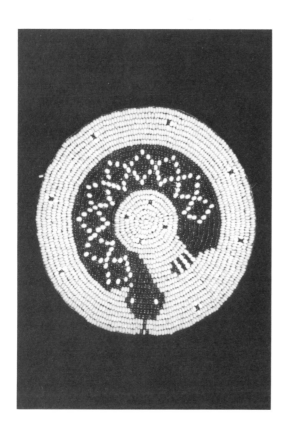

LEFT
Medallion, Dollie Calavaza
Zuni Pueblo
Glass beads
Acquired: Date Unknown
IAIA Permanent Collection: ZU-56

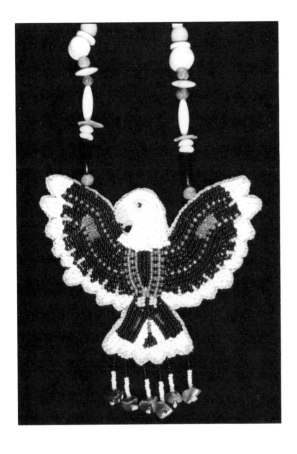

LEFT
Eagle Necklace, Dee Ross
Athabaskan
Glass Beads
4-3/4" x 4-7/8" x 1/8"
Acquired: 1979
IAIA Permanent Collection: ATH-18

BELOW
Beaded Medallion, Denise Davenport
Mesquakie
Glass beads, cloth
2-7/8" diameter
Acquired: 1985
IAIA Permanent Collection: MQE-3

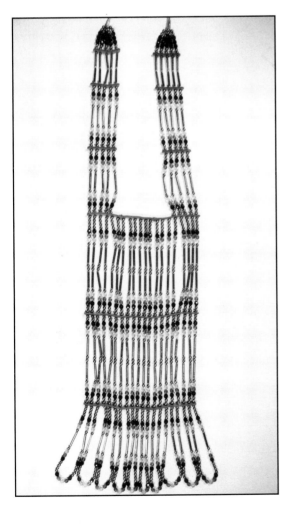

LEFT
Breastplate, C.J. Brafford
Sioux
Silver, glass beads
40" x 6"
Acquired: Date Unknown
IAIA Permanent Collection: PLN-27

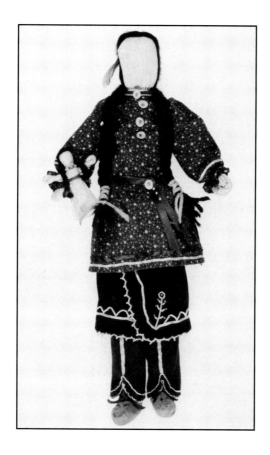

LEFT, TOP and BOTTOM
Cornhusk Dolls, Tammy Rahr
Cayuga
Cornhusk, cloth, glass beads
11-1/2" x 6" x 3"
Acquired: 1989
IAIA Permanent Collection: IRO-2, IRO-3

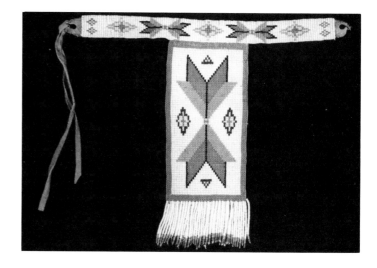

ABOVE
Beaded Choker, Denise Davenport
Mesquakie
Glass beads
12"
Acquired: 1985
IAIA Permanent Collection: MQE-2

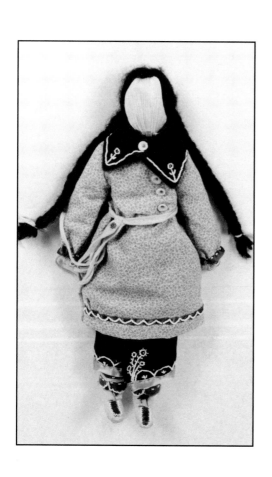

RIGHT
Roach Stick Headdress Ornament,
Murphy Bronco
Shoshone Bannock
Glass beads, feathers, wood
18-5/8" x 3-3/4"
Acquired: 1987
IAIA Permanent Collection: SS-14

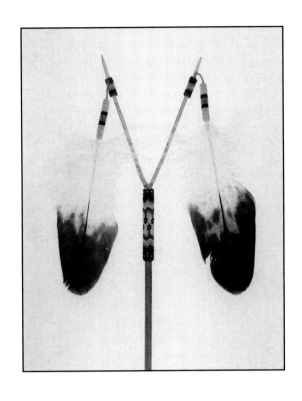

RIGHT
Pendant, Nathan Begay
Navajo/Hopi
Clay, leather, silver
2-1/2" x 2-1/4"
Acquired: 1981
IAIA Permanent Collection: H-135

LEFT
My first bracelet, B.K. McCurtain
Kiowa
Silver, coral, lapis, turquoise inlay
1-7/8" x 2-9/16"
Acquired: 1985
IAIA Permanent Collection: KI-43

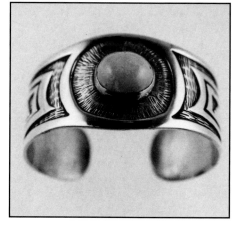

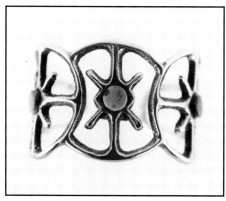

LEFT
Bracelet, Artist Unknown
Sandcast silver
1-3/4" x 2-5/8" x 2-1/8"
Acquired: 1962
IAIA Permanent Collection: PROP-400

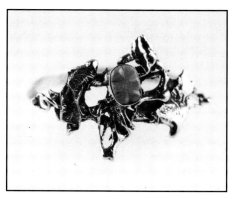

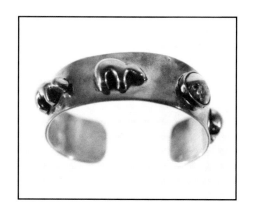

LEFT
Bracelet, Jennifer Parriette
Sioux/Ute
Brass, coral, ivory, coral, turquoise, silver
2-1/4" x 2-3/4" x 3/4"
Acquired: 1981
IAIA Permanent Collection: S-175

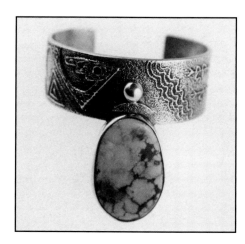

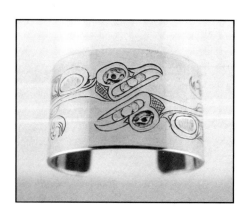

LEFT
Raven Bracelet, Larry Ahvakana
Eskimo
Engraved silver
6-1/4" x 1-1/2"
Acquired: Date Unknown
IAIA Permanent Collection: ESK-57

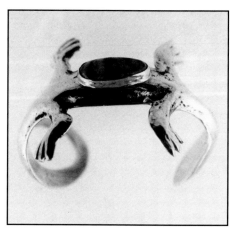

LEFT
Bracelet, Artist Unknown
Hopi
Silver, turquoise
6-1/2" x 1-1/4"
Acquired: Date Unknown
IAIA Permanent Collection: H-63

LEFT
Benedict Peltier
Chippewa
Silver, jet, wood, coral, ivory
2-3/16" x 3" x 1-5/8"
Acquired: 1966
IAIA Permanent Collection: Chp-81

LEFT
Bracelet, Jennifer Parriette
Sioux/Ute
Silver and turquoise
1-3/4" x 2-5/8" x 2-5/16"
Acquired: 1980
IAIA Permanent Collection: S-173

LEFT
Bracelet, Eddie Chavez
Cochiti Pueblo
Brass
1-3/4" x 2-5/8" x 1-1/2"
Acquired: 1981
IAIA Permanent Collection: CO-28

LEFT
Bracelet, Anthony Lovato
Santo Domingo Pueblo
Sand cast silver, turquoise
2" x 2-1/4" x 3/4"
Acquired: 1986
IAIA Permanent Collection: SD-5

LEFT
Bracelet, Marshall Ellis
Oneida
Silver overlay with Woodland floral patterns
1-5/8" x 2-1/2" x 1-1/2"
Acquired: 1977
IAIA Permanent Collection: ON-25

LEFT
Lizard Bracelet, Mike Lafferty
Sioux
Silver, turquoise
5" x 1/2"
Acquired: Date Unknown
IAIA Permanent Collection: S-31

LEFT
Bow Guard, Eddie Pacheco
Santo Domingo Pueblo
Leather, silver, turquoise
4-3/16" x 7-1/2"
Acquired: 1970
IAIA Permanent Collection: SD-83

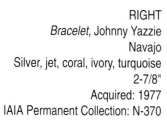

RIGHT
Bracelet, Johnny Yazzie
Navajo
Silver, jet, coral, ivory, turquoise
2-7/8"
Acquired: 1977
IAIA Permanent Collection: N-370

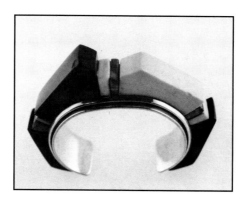

RIGHT
Bow Guard, Artist Unknown
Southwest
Leather, silver
7" x 3-1/2"
Acquired: Date Unknown
IAIA Permanent Collection: SW-20

RIGHT
Bracelet, Jerry Norton
Eskimo
Silver, ivory, wood
2-3/4" x 3"
Acquired: 1965
IAIA Permanent Collection: PROP-394

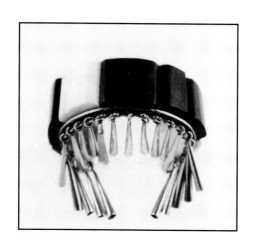

RIGHT
Belt Buckle, J. Lucero
Jemez Pueblo
Silver overlay with five turquoise stones
Acquired: Date Unknown
IAIA Permanent Collection: J-56

RIGHT
Bracelet, Monica Sioux King
Navajo/Hopi
Silver, jet, mother of pearl
2-1/2"
Acquired: 1977
IAIA Permanent Collection: N-367

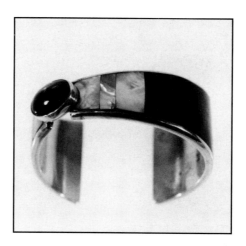

RIGHT
Belt Buckle, Peter Nez
Navajo
Silver overlay of bull rider
4-1/2"
Acquired: Date Unknown
IAIA Permanent Collection: N-242

RIGHT
Bow Guard, Ramus Pacheco
Navajo
Silver and turquoise on leather
5-1/2"
Acquired: Date Unknown
IAIA Permanent Collection: N-157

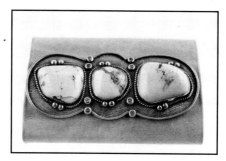

RIGHT
Belt Buckle, Joseph Antone
Papago
Sand cast silver with basketry design
2-5/8"
Acquired: Date Unknown
IAIA Permanent Collection: PA-13

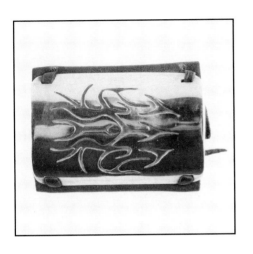

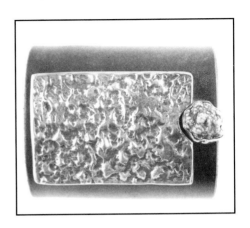

RIGHT
Bow Guard, Mark Suazo Hinds
Tesuque Pueblo
Leather, sand cast silver, turquoise
3-3/4"
Acquired: 1981
IAIA Permanent Collection: TE-3

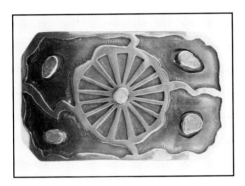

RIGHT
Belt Buckle, Artist Unknown
Hopi
Silver, turquoise
4-1/2"
Acquired: Date Unknown
IAIA Permanent Collection: H-209

RIGHT
Belt Buckle, Nelson Pacheco
Santo Domingo Pueblo
Silver, turquoise
2" x 3"
Acquired: Date Unknown
IAIA Permanent Collection: SD-51

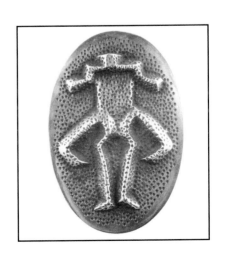

RIGHT
Belt Buckle, Artist Unknown
Southwest
Silver
3"
Acquired: Date Unknown
IAIA Permanent Collection: SW-131

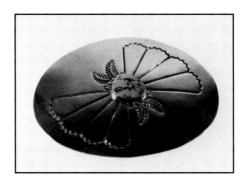

LEFT
Belt Buckle, Stanley Yazzie
Navajo
Silver, nickel, turquoise
3-1/2" x 2-1/2"
Acquired: 1984
IAIA Permanent Collection: N-91

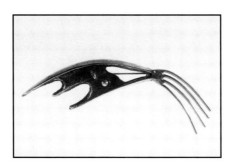

LEFT
Abstract Design Pin, Artist Unknown
Southwest
Silver, coral, turquoise
1" x 4-1/2"
Acquired: Date Unknown
IAIA Permanent Collection: SW-26

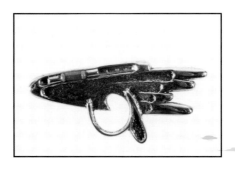

LEFT
Pin, Artist Unknown
Jemez Pueblo
Silver, turquoise, coral inlay
3-1/2" x 1-1/2"
Acquired: Date Unknown
IAIA Permanent Collection: SW-28

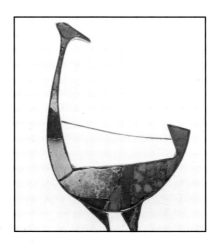

LEFT
Pin, Artist Unknown
Jemez Pueblo
Silver, turquoise, coral
5-1/4" x 3"
Acquired: Date Unknown
IAIA Permanent Collection: J-21

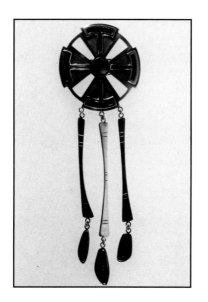

LEFT
Hair Barrette, Bennie Buffalo
Cheyenne
Silver and turquoise
7-3/4" x 2-1/2"
Acquired: 1968
IAIA Permanent Collection: CHY-36

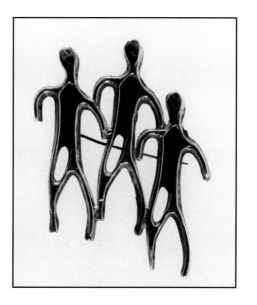

LEFT
Three Figures Pin, Jerry Norton
Eskimo
Sandcast silver
3-7/8" x 3"
Acquired: Date Unknown
IAIA Permanent Collection: NW-23

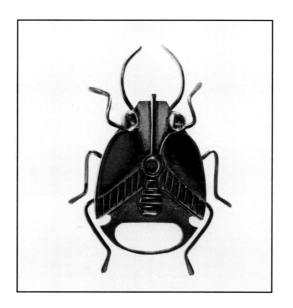

LEFT
Bug Pin, Dennis Apple
Sioux
Silver
2-1/2" x 1-3/4"
Acquired: Date Unknown
IAIA Permanent Collection: S-89

LEFT
Cuff links, Artist Unknown
Southwest
Silver
1-3/16" x 1-3/16"
Acquired: Date Unknown
IAIA Permanent Collection: SW-155

LEFT
Spoon, Artist Unknown
Southwest
Sand cast silver
8" x 2"
Acquired: Date Unknown
IAIA Permanent Collection: SW-103

LEFT
*3 Pieces Flatware Se*t, Roger Tsabeytse
Zuni Pueblo
Brass, turquoise
Fork: 8-7/8" x 1" x 1/2"
Knife: 9-7/8" x 1/2" x 1/2"
Spoon: 8-1/2" x 1" x 1/2"
Acquired: Date Unknown
IAIA Permanent Collection: ZU-62

LEFT
Spoon, Artist Unknown
Southwest
Silver, ivory
10-1/2"
Acquired: Date Unknown
IAIA Permanent Collection: SW-102

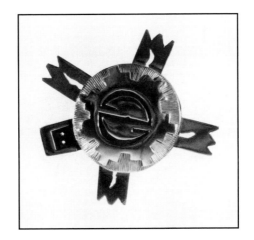

LEFT
Turtle Fetish, Artist Unknown
Southwest
Silver
1-1/4" x 1-1/2"
Acquired: Date Unknown
IAIA Permanent Collection: SW-23

LEFT
Elephant Hairclasp, Larry Ahvakana
Eskimo
Ivory, wood, gold
2" x 5-3/16" x 1-1/8"
Acquired: 1978
IAIA Permanent Collection: Esk-95

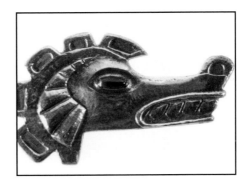

LEFT
Sea Wolf Pendant, Rudy McGeorgie
Tribal Affiliation Unknown
Silver cast with stones
3-1/16" x 5-3/8"
Acquired: circa 1967
IAIA Permanent Collection: PROP-406

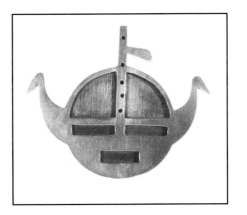

LEFT
Navajo Sun Symbol Pin, Artist Unknown
Southwest
Silver
2-1/2" x 2-1/2"
Acquired: Date Unknown
IAIA Permanent Collection: SW-25

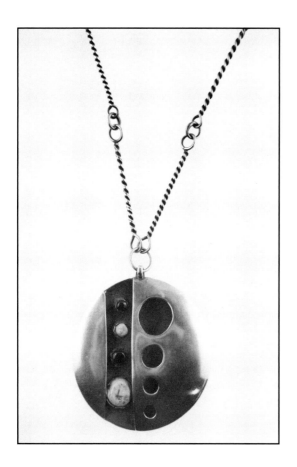

LEFT
Necklace, Roderick Tenorio
Santo Domingo Pueblo
Silver, jet, turquoise
8-3/4" x 6"
Acquired: Date Unknown
IAIA Permanent Collection: SD-31

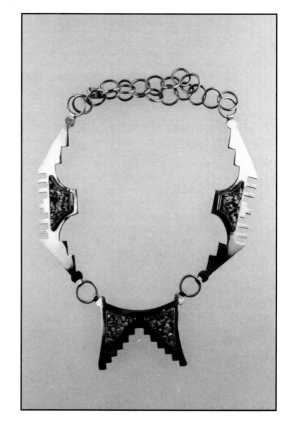

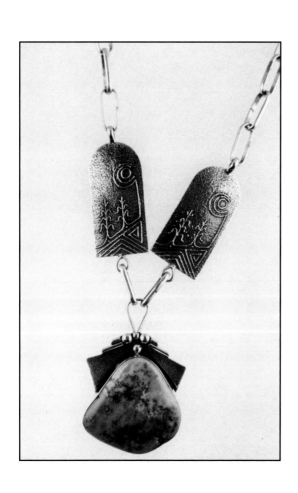

LEFT
Necklace, Anthony Lovato
Santo Domingo Pueblo
Silver with turquoise
14-3/8" x 1-3/4"
IAIA Permanent Collection: SD-15

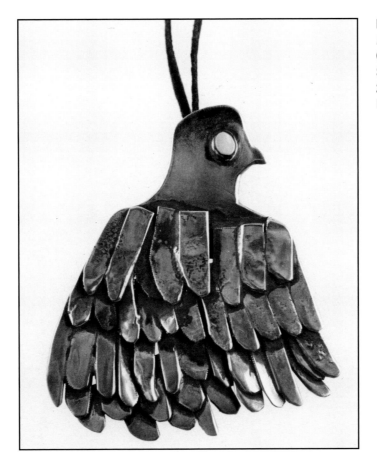

LEFT
Bird Pendant, Phyllis Fife
Creek
Silver with turquoise eye
2-1/2" x 3"
IAIA Permanent Collection: CK-21

LEFT
Necklace, Roderick Tenorio
Santo Domingo Pueblo
Silver with turquoise and jet
8-3/4" x 6"
IAIA Permanent Collection: SD-81

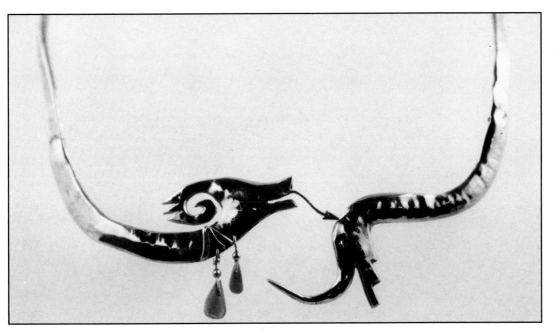

LEFT
Water Serpent Necklace, Artist unknown
Southwest
Silver, turquoise eyes, shell dangle drops
5-3/4" x 6-1/2"
Acquired: Date Unknown
IAIA Permanent Collection: SW-144

LEFT
Necklace, "Etta"
Southwest
Silver with coral and pipestone
5-1/4" x 3/4"
IAIA Permanent Collection: SW-145

BELOW
Necklace, Artist Unknown
Southwest
Silver with turquoise
22-1/2"
IAIA Permanent Collection: SW-143

LEFT
Ram Head Choker, Jay Bowen
Skagit
Silver
4-3/4" x 5-7/8"
IAIA Permanent Collection: SKG-2

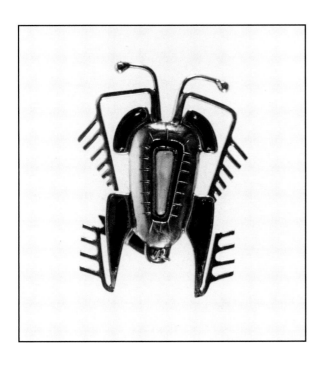

LEFT
Bolo, Artist Unknown
Southwest
Silver with turquoise and wood
2-1/8" x 1-1/2"
IAIA Permanent Collection: SW-156

BELOW
Drinking Cup, Monica Sioux King
Navajo/ Hopi
Silver overlay with turtle image
3" x 2-1/2"
Acquired: 1977
IAIA Permanent Collection: N-368

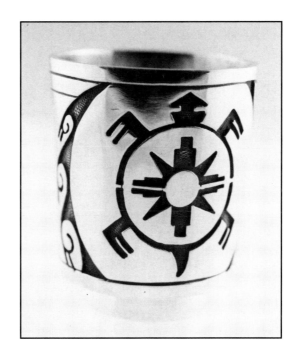

Like an actor who is mistaken on the streets for the character they portray, many Indian artists are forced into the awkward position of defending their real-life identity against the stereotyped views of Indian art patrons. Giving voice to native artists invites destruction of the silent myths about Indians and their art. Even so today's message of Indian art can be more powerful than the beautiful native image implies.

Nancy Marie Mitchell

Chiricahua Apache

ABOVE
Beauty at The Tokyo Bus Stop, Richard Begay
Acrylic on Canvas,
20' x 16'
IAIA Permanent Collection: N631

CHAPTER SEVEN
GIVING VOICE

In the following pages, Nancy Marie Mitchell, Chiricahua Apache interviews four separate Indian artists. The interviews are presented in an effort to gain insight into the contemporary Indian art world and the role of the individual Indian artist.

Think Indian artist. A tall young man. His long dark hair sways gently in the desert breeze. Bare-chested, his tight levis are pulled over expensive cowboy boots. He is a high mountain recluse, chiselling out brave warriors rhythmically to the silent heartbeat of his soul. Or perhaps the artist is a woman, an ageless beauty draped in heavy turquoise and wrapped in a Pendleton blanket. Her dark eyes lower in modesty over exquisite pots of essential female form. An Indian artist is often expected to look the part, to be "authentic." Voices of Indian artists are silenced by writers who try to interpret the significance of their art. The artist is spoken about, but is he or she spoken with?

In our most accessible forms of popular culture, including museum catalogues, tourist guides and beautifully illustrated Indian art books, American Indian and Alaska Native voices are greatly restricted, if not muted. Rarely is an Indian artist granted more than a sentence or two of their own words and then only to confirm the

spiritual significance of their work. (1) Artists who make themselves heard about other issues are not included in glossy coffee-table books where the pots, blankets, and sculptures are dramatically cast against setting suns. (2)

Consequently, our understanding of contemporary Indian art is greatly handicapped. To comprehend the relevance of contemporary Indian art today, one must consult the artist.

Conversations

Let's start with a simple question – "Why do Indians make art?" (3) What if we ask the Indians themselves? This was the thinking behind 24 conversations taped in Santa Fe last year. Our interest at IAIA was not only the motivation of individual artists, but also their understanding of variables such as market pressures, gender, ties to traditionalism and audience.

As one subject led to another it became evident that there is a great complexity and amount of cultural negotiation involved in producing and selling Indian art in Santa Fe. What does it mean to artists when the majority of their work is owned by non-Indians? How does one justify breaking with cultural norms in order to advertise themselves? And how do artists deal with the persistent question of "are you an artist, or an Indian artist?"

The answers to these questions were as varied as the individuals consulted, however several themes emerged:

Double Cursed and Twice Blessed – The needs of the mainstream art world appear to run contrary to the realities of the Indian art world.

Censorship – The marketplace tries to restrict imagery used by Indian artists to maintain stereotypes.

Labels Don't Describe – Artificial labels attached to Indian art tend not to describe, but to hinder understanding of the work.

BELOW
Ye ii Impersonator, Larry Yazzie
Navajo
Silkscreen 22-1/2" x 16"
Acquired: 1985
IAIA Permanent Collection: N-12

Double Cursed and Twice Blessed

Western definitions of an artist were often found to be in opposition to the popular culture's definition of an Indian artist. (4) The equation works like this color: "a true artist" produces without constraints from the market on content or style. (5) No artist wants to be known as a "sell-out," (6) a person who prostitutes cultural value for commercial success. However, the force of market constraints are so strong in the arena of American Indian art, that any deviance from set role models results in rejection in the market place. The Van Gogh syndrome of Western art, a need to be different, on the cutting edge, requires non-conformance. Simultaneously, the Santa Fe Indian art market requires conformity.

Fine arts in this country has come to mean art without culture. If you produce artwork and are known as an Indian, then you are automatically no longer a candidate for inclusion in the fine arts world. Indian art is minimalized by definition. And so are Indian artists. Take away the ethnic qualifier, take away the culture, then you can enter under the sign that simply says ARTIST. (7)

Contemporary Indian artists seem to be caught in a no-win situation – "double cursed and twice blessed." (8) If the artist meets the standard Western definition of an artist, they can no longer claim a relationship to their heritage. If the artist conforms to the image of an Indian artist, he is excluded from serious consideration in the fine arts world. Contemporary Indian artists constantly face choices concerning their acceptance or rejection from separate communities.

CENSORSHIP

The fine art world maintains that censorship is a violation of the artist's rights. No one should dictate to an artist what they can produce. However, a majority of Native American artists have to face an imperative by gallery owners to produce recognizably Indian art, sometimes of a religious subject matter that in itself may be objectionable to traditional Indian elders. Although artists of all backgrounds have to contend with the demands of the market, Native American artists wrestle with the potent mandate of producing decorative arts. The manipulation of conflicting expectations and roles became my center of interest. These survival strategies form the basis of the stories shared here.

LABELS THAT DON'T DESCRIBE

The practice of labelling has probably been one of the greatest roadblocks to the free acceptance of the evolution of contemporary Indian Art. Art historians, dealers, gallery owners, and collectors all benefit from a clear delineation of styles. These descriptive categories usually range from traditional to modern, or individual. (8) Native American artists who use political subject matter in their work are often classed in such a way that their work is excluded from catalogues and publications.

Yet another dimension involved in the act of labelling concerns an artist's alignment with other Native American artists or assertion of one's right to prioritize the work over an ethnic identity. The question of identity is so controversial that it has polarized the community of Indian artists between those desiring inclusion on the basis of tribal background and those who prefer simply to be known as an artist without the ethnic qualifier. Although the controversy seems at times to revolve simply around semantics, the situation has gotten hot, it is virtually impossible to even discuss the issues for fear that you will either sound as if you want to throw your identity out the window, or that you are abusing your heritage by using it as a tool of promotion. (9) As labels are generally imposed from the outside, Indian artists have to rely on their own skills at manipulating these standards to meet their needs.

A DAY IN THE LIFE

At 32, Darren Vigil Grey is already a mature painter, although he's quick to add that, "there's so much serious art happening right now, I feel that I'm just barely getting somewhere … where I feel like I have something." Grey, who was raised on the Jicarilla Apache reservation, first came to study at the Institute of American Indian Arts at the age of 15. Now well-established in his career, Grey spoke of the various phases through which he saw his art evolving, from regional depictions to less representational canvases. His determination to maintain integrity in his work is reflected in the following passages.

"I was working on a mountain spirits kind of thing. That's a long story in itself, but he (the gallery owner) managed to sell a lot in that summer and that fall. When he came to see the new work … I had finished that series and it was kaput no more … and he saw my new work, he didn't like it. I said, 'well, there's no need for me to be in your gallery.' I just told him straight out. And he looked at me, and then his wife, and said, 'I guess you're right.' And we cut it right that day. Boom. He sent all my work back here, and I was without a gallery for about a year and a half … I was basically trying to use that image (mountain spirits) to get through some things I had dealt with when I was a kid … with the mountain spirits dancers and stuff and you don't want to give away too much in images … for me to say this is what this means. And I just wanted to rely on the mysterious aspects of it because, let's face it, non-Indian people will never understand. They just never will understand. Some do, you know. Some do grasp onto it. It changes their lives. But for the most part, people are just not aware. There is so much that they just don't possess. And so in that aspect I just wanted to … create something that was moving, and I think I did. But that was a good experience. It made me feel good that I could just say … 'Well I don't need you, then. You don't need me, I don't need you.' And we broke it off that second. Boom. We're sitting here, and it was just right before summer … last summer … when I did this, and I thought I was going to have a show in the summer, and I was looking forward to all this, and high hopes, and a gallery downtown, Indian Market show, and I just said goodbye to it in a split second by saying, 'Well, there's no need for me to be in your gallery, then, huh?' And he said, 'Nope.' And he left out the door."

"I felt kind of rejected. I accepted it. But that's nothing new to me. I've been rejected so many times with my art, it's not funny. It's just a day in the life. And I went without a show, no gallery, all summer long. And I struggled, but I kept painting because I had other things to do … it all worked out."

During the interview Darren Vigil Grey voiced a similar long-range philosophy on the process of constructing an Indian aesthetic and sense of identity. His concluding words affirm the sense of commitment voiced by the five artists featured here.

VIGIL GREY

NMM – "How do you feel about the labelling? Is it something that you participate in or you choose not to?"

DVG – "I choose not to. I've never, ever been considered that, either. At different points of my career, I obviously used Native American imagery … symbolism and stuff. And that's what I am. I can't pretend to be like this Anglo person trying to fit in somewhere. I just won't do it. I think if you looked at my current art, you would probably know that this is probably some person with some ethnic origin. In all the shows I've done they've just kind of accepted me for who I am and I like that."

"I like to be accepted across the board. With other artists. I don't think there should be so much … there again, they're categorizing once again. They're sticking us in our little niche, saying, 'If you be a good little Indian, we'll give you this little place over here.' I'm tired of all that. But it's going to be a long road. Just like the last 300 years. It'll probably take another 300 years." (10)

Insight Comes From Inside

Marcus Amerman, Kiowa, is an eclectic artist who combines humor and a sense of traditionalism in his work, although best known for his beadwork on clothing, purses and jewelry.

Amerman is also a painter. As I looked through a photo book of his work, we spoke of the pressure to market a consistent product.

"I think I'm always sort of sensitive to what's going on around ... I've got a trash dump out on the edge of our land and I've been using a lot of objects ... recycling ... I'm always open to change. That's my whole thing. I like to keep changing, doing something new ... I can't imagine really settling down and doing style ... just try to do something different, so I'm always looking for something new."

NMM – "Do you depend on sales? A lot of people ... stick with the same style because they're depending on sales. Does that restrict you?"

MA – "Not really. A lot of my stuff is pretty consumable. Like these brace-lets and jewelry ... it goes pretty well. But it has taken a few years. I don't think I still really do it very well."

NMM – "These are amazing. What don't you do very well?"

MA – "The business end. A lot of these galleries ... they always want you to keep in the same thing. There's always that pressure ... to keep reproducing."

AMERMAN

NMM – "What do you think the role of an artist is, or should be?"

MA – "Traditionally, I guess it's sort of like the artist/magician … it's tied in a lot to shamanism … but anyway the artist was always part of society, there was always a space for him. In western culture he's always been sort of apart. The post-Modernist sort of artist … he's supposed to be more in touch with his audience and society … belong to it … the loner sort of thing isn't holding up anymore."

NMM – "Where do you stand with that?"

MA – "I'm in the middle there some- where. I want it to be seen, I want it to be recognized and valued. I want my idea to get out there, but I like just creating what I think of and not what is dictated to me by collectors. Insight comes from inside, I don't want some- one channelling me."

MA – "The reason no one changes is because … they want to find a niche … a hole to settle into, just keep those checks coming. I don't see a lot of continual thought process in people's work. It's usually … you see the same things over and over again. That's why with me, I think where I stand is, I value the respect of my peers."

NMM – "I like your incorporation of these personalities that inform on American culture … popular culture in general. I hardly see anyone else in that. I wonder what is your thinking behind it?"

MA – "Well see, buying art is like painting and sculpting. It's western. It belongs to western culture. If you do a painting … Janet Jackson … or a sculp- ture then its like you're doing some- thing … like you're going over into the western culture. It just doesn't work. With beadwork, you're taking it back there. It becomes Indian. Janet Jackson becomes Indian."

Beautiful Indians
on Top of a Hill

Jean La Marr came to Santa Fe as a Professor at the Institute of American Indian Arts in the printmaking department in 1990. Of Paiute and Pitt River tribes, La Marr relocated to the Bay Area of California where she attended art school at UC Berkeley. Our conversation concerned the reception of her politically-oriented artwork within the Indian art market:

JLM – "Well my work was political, and I was never allowed … never invited to participate in any Indian art shows because my work was political. And so I would show with other political artists in the Bay area, or multi-cultural Chicano artists. Mostly Chicano artists would invite me to their shows. I was their token Indian. We tease about it now because I went to the big opening of the CARA show at UCLA – Chicano Art Resistance and Affirmation. Beautiful show. They said they were going to make me an honorary Chicana if I could learn how to roll my 'Rs.' So we communicate well, and their work is very firm, very political, very up-front, narrative work. I see people doing artwork now, especially Indian people right now, are saying they are doing political artwork, but it's very vague, it's very decorative, it's very pretty. If you didn't read something on the side that told you that, you wouldn't believe it … that it was political. So, I come here from where they were, very overtly political in their work. They made statements in their work.

So, that was my grounding. I found out that I wasn't invited to that Women of the Sweetgrass Cedar and Sage show. The book is so much. Everybody wants the book and it's still used in all the universities. But I was left out of there because my work was too political, and the curators said that only men did political artwork. So the women were being prejudiced."

NMM – "Is the market influence something that you struggle with? Is there any self-censorship that goes on about … how is this going to be received? Is there anything that happens along those lines?"

JLM – "I do what I want to do."

NMM – "You've been successful in marketing it without having to compromise?"

JLM – "No, I've never had to compromise, and I don't feel like I should. I guess it's so blatant down here in Santa Fe … the market, and it tells what Indians have to do. I have a problem with my own students. I'm telling them one thing … I tell them do what's coming from you, what you feel, and everything else. But the Santa Fe market is telling them … .do beautiful Indians on top of a hill. And so, who are they going to believe? This one person that's preaching to them all the time about it? Or this market with hundreds of galleries that are selling Indian art that has pretty Indian scenes in it, the humble beaten Indian?"

NMM – "Are you able to market in Santa Fe?"

JLM – "No."

NMM – "Do you choose not to?"

JLM – "Well, I don't think there would be a market for me here in Santa Fe because of my political artwork. They don't want to hear about Indians."

JLM – "Because I recognize that there are certain audiences, and I try to keep my work in museums and institutions of higher learning … galleries, non-profit galleries … people who are sensitive and understand … because I feel like my work needs some kind of artistic intelligence … recognizing what has happened to Indian people … are aware of what's happening in current events. Because I feel like my work communicates to the non-Indian world, my work is specifically oriented to communicate to non-Indian people, and I feel like I have an international language, so it can reach international people. It's a kind of non-verbal communication … I try to use symbolism … I feel that might represent something that other people might recognize."

LA MARR

LA FOUNTA

The Dilemma of the Innovative Artist

Presley La Fountain got a jump start in the contemporary Indian arts scene straight out of IAIA by working with artists Doug Hyde, Earl Biss, Kevin Red Star and others. As one of the more visible sculptors today, La Fountain's perspective on the classification game is expansive. As we looked through an exhibit catalogue which divides Indian art into historic, traditional, modern, and individualist categories, La Fountain had the following to say about labelling:

PLF – "You've got to keep yourself open. If you're an Indian person you have to have, I think, some kind of … something inside you that keeps you open to other Indian artists and craftspeople, because you're Indian and you're part of the larger family. That's why wherever we go, we go up to each other and say, 'Hey, how are you, where are you from, what's going on?' And I don't think people should lose that. Because it's a real communal thing. You asked me a question … if it all fits categorically, or does it work for me? To me, it's like the age-old question of what is and what isn't Indian art? We're at such a young stage of growth of Indian people … contemporary Indian people. As far as people from the 40s until now, I think that's just a seed and a part of a larger movement that will happen. We just got exposed to the traditional carving techniques and tools of the Europeans as far as stone sculpture and bronze are concerned … foundry work. Also contemporary jewelry. It's just way too early to tell and categorize as far as I'm concerned. I mean what is it now? It's only 1991. That's nothing. I mean we've got another 100 years before I think you'll see some direct schools. A lot of it is still growing and its changing so rapidly, I think, before any catalogue book or anything is going to have its inherent philosophy because it's too early to tell."

NMM – "How would you describe your work? Would you use one of these things? Modernism or Individualism?"

PLF – "Myself? If I put myself in here after I said all that … I think it's the ethnic art market and the dilemma of the innovative Indian artist. Now. That's the category I want to be in. I don't know. Put me in with these guys right here."

NMM – "Who?"

PLF – "These guys here. Smoking a pipe here. These old Indian guys. With headdresses. Here you go. Put me with these guys."

Behind Glass

As American Indian artifacts have been taken from home communities to be carefully guarded in museums behind glass, so too have the intricate belief systems of practicing artists been encased in predetermined fields of inquiry. American Indian artwork becomes more meaningful, not less so, by placing it in the context of living producers. The clouds of mystery surrounding Indian artists, and more specifically, Indian artists in Santa Fe, have clearly served as an effective marketing device for the tourist trade. Stripped of the hype and the glamour characterizing Indian artists, there lies conflicts, strategies, aspirations and frustrations. The addition of a real-life component to the study of Native arts grants an essential humanness to artists that is invisible if one relies solely on impressions gathered from strolling around the plaza in downtown Santa Fe. The romantic image of a silent Indian artist can not continue to stand outside the galleries and museums, like cigar-store Indians, beckoning one to come in. The artists interviewed provoke more questions than provide answers. We need to hear more from them about their work. Perhaps by giving voice to their concerns, more can be gained than what has been written and exhibited in the past. Indian art through Indian eyes must also have the Indian voice to express what it all means to the Indian people who created it.

RIGHT
9 People, 1 Dog, Alice Loiselle
Chippewa
Oil on Canvas
60" x 50"
Acquired: 1968
IAIA Permanent Collection: CHP-29

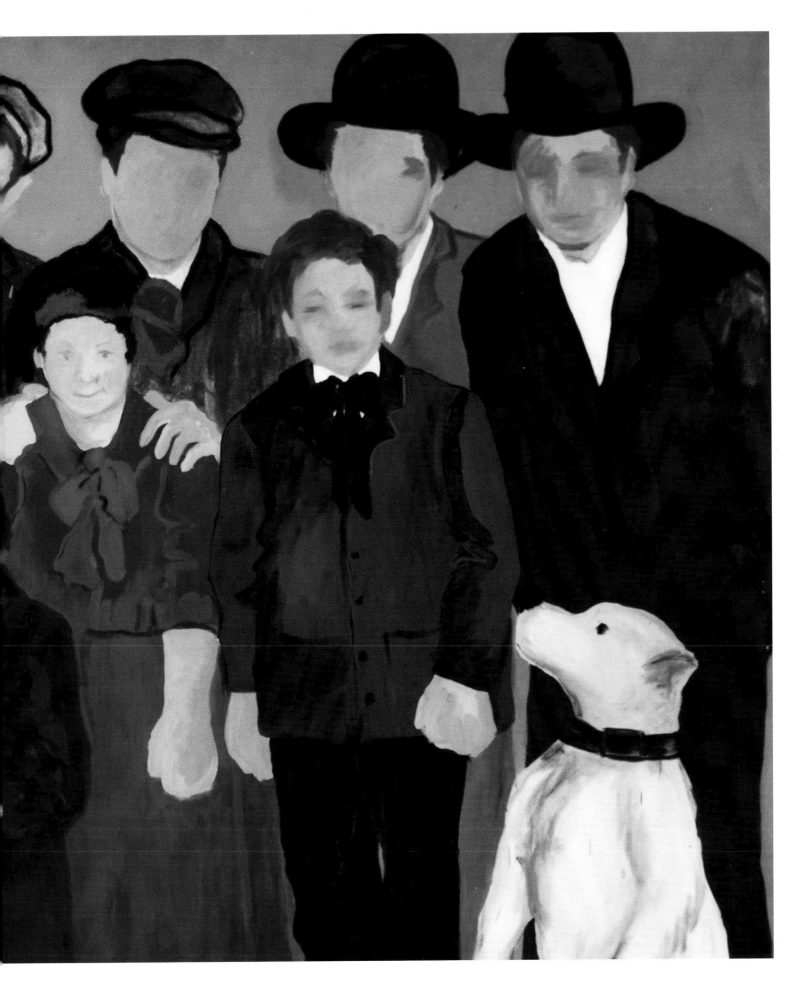

Although Indians of the past probably never considered themselves to be practicing artists in pursuit of art for it's own sake, art was nonetheless integral in the growth of Indian culture. For them, art and culture are inseparable – art is essential to the shaping of culture and simultaneously shaped by it.

During the earliest stages of Indian cultural development, religion soon gained a central position. And while Indians depended heavily upon ritual and language to convey religious thoughts, art was the major vehicle for setting the stage for religious consumption. The distinctiveness of Indian culture, including religion, could best be realized and given its most tangible and concrete form through the use of visual symbols, or as experienced through the drama of ceremonial story-telling and theater-like religious pageantry, usually heavily dependent upon dance and music.

Through the ages ancient cultures have been largely defined by the arts. It stands to reason that the task of projecting a healthy, supportive cultural setting into the future will depend even more heavily upon a dynamic employment of the arts. It can be predicted that the workload of the arts as the definer and carrier of Indian culture will increase should the once-vital religious forms become more diffused and the use of tribal languages decline. With the inevitable erosion of older tradi-tional nature-centered ways of life, it becomes more essential that new forms of Indian art and culture are creatively brought together. A valid new Indian cultural framework must be formed, one that can serve the specialized needs of Indians far into the future.

Dependence upon the arts for communication and human enrichment is not new for Indians. Archaeological records reveal the existence of 10-thousand-year-old crude stone palettes smeared with varied colored earth pigments, indicating a concern and fascination with the use of color – speculatively – in ways that could have run the gamut from body painting to the symbolic marking of weapons and tools. It can be assumed that visual symbols and designs abounded in the decoration of simple utilitarian items, shelter forms, religious paraphernalia, various forms of costume design and personal adornment. Other ancient artifacts of that early period reveal an ongoing aesthetic concern for shape and form, as can be seen in the magnificently shaped stone spear points produced at the time. Evidence of iconographic design prowess dates back for centuries in the form of a ubiquitous outpouring of highly stylized and abstracted petroglyphs and pictographs. Cave walls, ceremonial chambers and animal hides were richly decorated with painted animal and human figures. There was also widespread dependence on the performing arts:

music, dance and elaborate ceremonial dramas- ranging from the chanting of a single magically equipped shaman to the splendorous displays of tribally evolved religious pageantry, involving everyone in the community.

At the time of contact with Europeans, wide spread evidence points to a high-level attainment in the practical arts and architecture. Following the coming of powerful alien groups to the shores of America, indigenous ways and culture in general went into a state of decline and chaos; and with it a deterioration in the dynamic force of the arts as a major cultural delineator. Today an increasing number of Indians participate successfully within the broader culture, relative to the social conditions of Indians as the worst in the United States today.

Whatever goals the Institute of American Indian Arts may adopt as a developing educational institution, it has a very special responsibility for redoubling its efforts to link the cultural greatness and disciplined ways of the Indian past to the creative productivity patterns of upcoming generations. It must continue to refine its inevitable record in the use of the arts to search for those everlasting cultural truths that can be used to rebuild Indian pride and identity. It must serve as a base from which living Indians can spring to their rightful and honorable place in contemporary world society.

With the opening of the IAIA Museum in downtown Santa Fe in a first class facility and the promise of the new national museums to open soon in New York and Washington, DC, Indians will have opportunities to gain perspectives on their own cultural accomplishments in ways never previously afforded.

The task of finding new operable bases is a formidable one for all concerned – requiring the perfection of educational methodology in a largely untried field of social engineering, in which open-ended learning can take place against a background of Indian pride.

On the IAIA campus of the future, learning to cut the educational cloth to fit each member of it's student body constitutes a major challenge. Being Indian today is a highly individualistic proposition, with each student finding himself – by way of varied patterns of upbringing and experiences – at a different comfort position of the scale of being Indian. Some students who come from home settings rich in tribal ways and values seek only a sympathetic environment in which to grow. Others choose to conserve these ways at any cost. Learning for them is a matter of stabilizing a world in which their feelings and identities as Indians can remain central to their existence. Others – equally proud of their Indian origins – may choose to expand learning outwardly and away from an Indian

core – consciously or unconsciously modifying, abstracting, and stretching tribalistic ways to fit their individual needs as members of a contemporary bi-cultural world.

In another category, some students come from non-traditional settings where to be Indian carries a different meaning. Such a category may include those who know little of traditional tribal ways, but come to IAIA to learn more about themselves and what being Indian means. Among this group may be found those who actively search for ways to strengthen their identity as Indians through vicarious means: association with more traditionally oriented friends and peers, participation in traditional activities, such as pow wows, religious events, or attending formal cultural study courses. Participants from this group vary from the passionate reactionary cultural fetishist to the cool bystander, or even to the rejectionist who makes little of his Indian background. All can learn how to reconcile their varying positions in an atmosphere of personal freedom, without any sense of having their culture rammed down their throat. Meeting the needs of students at both ends of the identity scale defines the complexity of the educational task.

It can be assumed that the developing program on the future IAIA campus and that of the new downtown museum will be an elaborate extension of the original Institute of American Indian Arts program launched in 1962, the first significant educational institution to formally use Indian art in concern for culturally unique traditions. It is the foundation upon which to build an open-ended and freewheeling identity-and pride-building curriculum.

RIGHT
Untitled, Elizabeth Abeyta
Navajo
Clay
32" x 50"
Acquired: 1988
IAIA Permanent Collection: N-920

IAIA Museum Staff

Richard Hill, Sr. – (Tuscarora) Museum Director
Ray Gonyea – (Onondaga) Assistant Museum Director
B. Lynne Harlan – (Cherokee) Curator of Exhibitions
Lynne Brittner Hutton – Curator of Collections
Luis Neri Zagal – Conservator
Cande Routt – (Chippewa/Sioux) Museum Technician
Aubrey Singer – (Santa Clara Pueblo) Computer Operator
Larry Phillips – (San Juan Pueblo) Exhibit Preparator
Edie Jojola – (Laguna Pueblo) Senior Secretary
Clayton Brascoupe – (Mohawk) Museum Preparator
Paul Tioux – (Sioux) Museum Preparator

Exhibition Staff

Exhibit Designer – Andrew Gartner – Design Techs, Santa Fe, NM
Fabrication Designer – Chuck Dailey – Dean, Museum Studies
Photographers – Larry MacNeil (Eskimo) and Larry Phillips (San Juan Pueblo)
Audio Exhibition – Bruce King (Oneida)
Catalog Designer – Michael Gray (Chippewa-Cree)
Video Interviews – Phil Lucas (Choctaw)
Jewelry Consultants – Manuelita Lovato (Santo Domingo Pueblo),
Roger Tsabeytse (Santo Domingo Pueblo)
Interactive Video Producer
North Communications, Inc., Santa Barbara, California

Museum Studies Students

Linda Cywink (Potowatami), Brenda Hill (Narragansett), Lydia Jennings (Oneida), Patsy Farris, (Cherokee), Clara Casso (Cherokee), Glen Gomez (Pojoaque/Taos Peublos), Scott Jones (Comanche), Yvonne Lever (Delaware), Fred Nelson (Navajo), Roger Perkins (Mohawk), Christopher Ross (Navajo), Maxine Touchine (Navajo), Beaver Toya (Jemez Pueblo), Connie Yellowtail Jackson, (Crow), Faye Spoonhunter (Sioux), Lloyd Tillman (Shoshone), Kenneth Sahmie (Warm Springs), Tahlee Redbird (Kiowa), Glen Nipshank, Canadian (Cree)

Notes

Chapter 1

1) *Indian Artists*, 1977, American Indian Society of Washington, DC, Via Gambero Gallery, Washington, DC, 1967.

2) "Return of the Red Man," *Life* magazine, 1968.

3) "Through Spirit Hole I Go," *New American Art*, Vol. 4, Stetter Gallery, Phoenix, AZ, 1990.

4) George Morrison, "Artist's Statement," *Horizon Series*, Hazel Belvo, Editor, 1987, unpublished volume.

5) Ruth Phillips, *Patterns of Power*, McMicheal Canadian Collection, Kleinburg, Ontario.

Chapter 2

1) Richard Hill, *Art of the Iroquois*, Exhibit Brochure, Erie County Savings Bank, Buffalo, NY, 1973.

2) Michael Hartranft, "Littlebird Carries on Tradition," *Southwest Storyteller's Gazette,* Vol. II, No.1 and 2, Fall/Winter 1988.

3) Winona Garmenhausen, *History of Indian Arts Education in Santa Fe,* Sunstone Press, Santa Fe, NM, 1988.

4) The Institute of American Indian Arts Alumni Exhibition, Amon Carter Museum of Western Art, Fort Worth, TX, 1973.

5) Anthony Gauthier, Personal interview, IAIA Museum, 1991.

Chapter 3

1) Peter B. Jones, Statement of purpose, typed manuscript, IAIA Museum, n.d.

2) Earl Biss, Handwritten statement, n.d., IAIA Museum.

3) Earl Biss, Artist quote, Paintings by Earl Biss, Museum of the Plains Indian and Crafts Center, Indian Arts and Crafts Board, Browning, Montana, 1972.

4) Earl Biss, Artist's Brochure, n.d., IAIA Museum.

5) 1967 article in *Life* magazine.

6) Allan Houser, Instructor Evaluation, IAIA, n.d.

7) Sculpture By Doug Hyde, First One man exhibition, Museum of the Plains Indians, Indian Arts and Crafts Board, Browning, Montana, 1971.

Chapter 4

1) Kyle Lawson, *Dan Namingha Captures Hopi Spirit In Art*, Marquee, *The Phoenix Gazette,* November 14, 1981.

2) Jamake Highwater, *The Sweetgrass Lives On,* Lippincott & Crowell, Publishers, New York, 1980.

3) *New Visions - an exhibition of recent works by five leading Contemporary Native American painters,* Montana Arts Council, n.d.

4) T.C. Cannon, Handwritten document, dated March 10, 1966, IAIA Museum, Santa Fe, NM.

5) Lloyd Kiva New, Letter to the National Hall of Fame for American Indians, Feb. 23, 1988.

6) *Magic Images,* Philbrook Art Center, Tulsa, OK, 1981.

7) Wendy Wilson, *A Long Search,* a Poster, *Artists of the Sun,* August 14, 1980.

8) Kyle Lawson, *Dan Namingha Captures Hopi Spirit in Art,* Marquee, *The Phoenix Gazette,* November 14, 1981.

9) Pan Hait, *Reaching Out, Reaching In, Air & Space,* Vol. 1, No. 2, June/July 1986.

10) Jamake Highwater, *The Sweetgrass Lives On,* Lippincott & Crowell, Publishers, New York, 1980.

11) Artist's Statement, *Restless Native – David Bradley,* Plains Art Museum, Moorhead, MN, 1991.

12) Jo-Ann Swanson, Kevin Red Star, *Southwest Art,* Santa Fe, NM, July 1990.

13) Jo-Ann Swanson, Kevin Red Star, *Southwest Art,* Santa Fe, NM, July 1990.

14) Lloyd Kiva New, Letter dated March 26, 1965, IAIA Museum.

15) Ceramic Sculpture and Paintings by Larry DesJarlais, Southern Plains Indian Museum and Crafts Center, Indian Arts and Crafts Board, Anadarko, OK, 1989.

16) Artist Statement, typed manuscript, IAIA Museum, n.d.

17) John Villani, "A New Generation Breaks From Tradition," *New Mexico* magazine, Santa Fe, NM, 1991.

18) Peter B, Jones, Statement of Purpose, typed manuscript, IAIA Museum, n.d.

Chapter 5

1) Jamake Highwater, *The Sweetgrass Lives On,* Lippincott & Crowell, Publishers, New York, 1980.

2) Bob Shelton, "A Blending of Cultures," publication unknown, n.d.

3) Alex Jacobs, Typed manuscript, IAIA Museum, 1977.

4) Alex Jacobs, Typed manuscript, IAIA Museum, 1977.

Chapter 6

1) Drawings and Paintings by Alfred Young Man, Exhibition brochure, Indian Arts and Crafts Board, Museum of the Plains Indian and Crafts Center, Browning Montana, 1973.

2) Wapp, Exhibit Brochure, Museum of the Southern Plains, Indian Arts and Crafts Board, Anadarko, OK.

Chapter 7

1) For examples of this treatment see Guy and Doris Monthan, *Indian Art and Individualists,* Northland Press, 1975; p.40 and 140. Also Lois and Jerry Jacka, *Beyond Tradition,* Northland Publishing, 1988; pp. 169-181.

2) This point is most clearly demonstrated by exclusion from exhibits and texts, however, for an examination of Native American political art see Rick Hill, "It is a Good Day to Make Art!" *Indian Market, SWAIA,* 1991. Also Karen Duffek and Tom Hill, *Beyond History,* Vancouver Art Gallery, 1989, and Alfred Young Man, "Toward a Political History of Native Art," *Visions of Power,* The Earth Spirit Festival, 1991. My use of the word "neutralized" is derivative from Bob Haozous, Interview with author, December, 1991.

3) One only has to open the current issue of *American Indian Art* magazine, or consult the latest *SWAIA* catalogue to confirm that object fetishism rules. This is, of course, the objective. The author recognizes that varied disciplinary agendas (art history vs. anthropology) contribute to situation she critiques.

4) Rayna Green suggests that images of American Indians in popular American culture say more about the operative values of Anglo culture than the "reality" depicted. See Green, "The Indian in Popular American Culture," Vol. 4, *History of Indian-White Relations* (Wilcomb E. Washburn, Vol. Ed.), *Handbook of North American Indians* (William C. Sturtevant, General Ed.), 1988.

5) Rick Hill, Interview with author, March, 1991.

6) I am indebted to Warren L. d'Azevedo's work on the *Artist's role in African societies.* See d'Azevedo, *The Artist Archetype in Gola Culture,* Univ. Nevada/ Desert Res. Inst., 1966.

7) See Clement Greenberg, *Art and Culture,* Beacon Press, 1961; p.8 for "Artist's Artist."

8) Even though some forms of commission work are seen as legitimate, the circumstances in which the work is produced must be carefully handled so as not to appear deliberate.

9) See a description of Martin Puryear's work for an example of how an "ethnic" artist can made it big. Acceptance in New York City requires "a lack of defensiveness about mainstream American art." Michael Brenson, "Struggle to Fuse Culture and Art," *New York Times,* October 29, 1989.

10) Darren Vigil Grey, Interview with author, August, 1991.